IMAGES
of America

SAN DIEGO'S
NORTH PARK

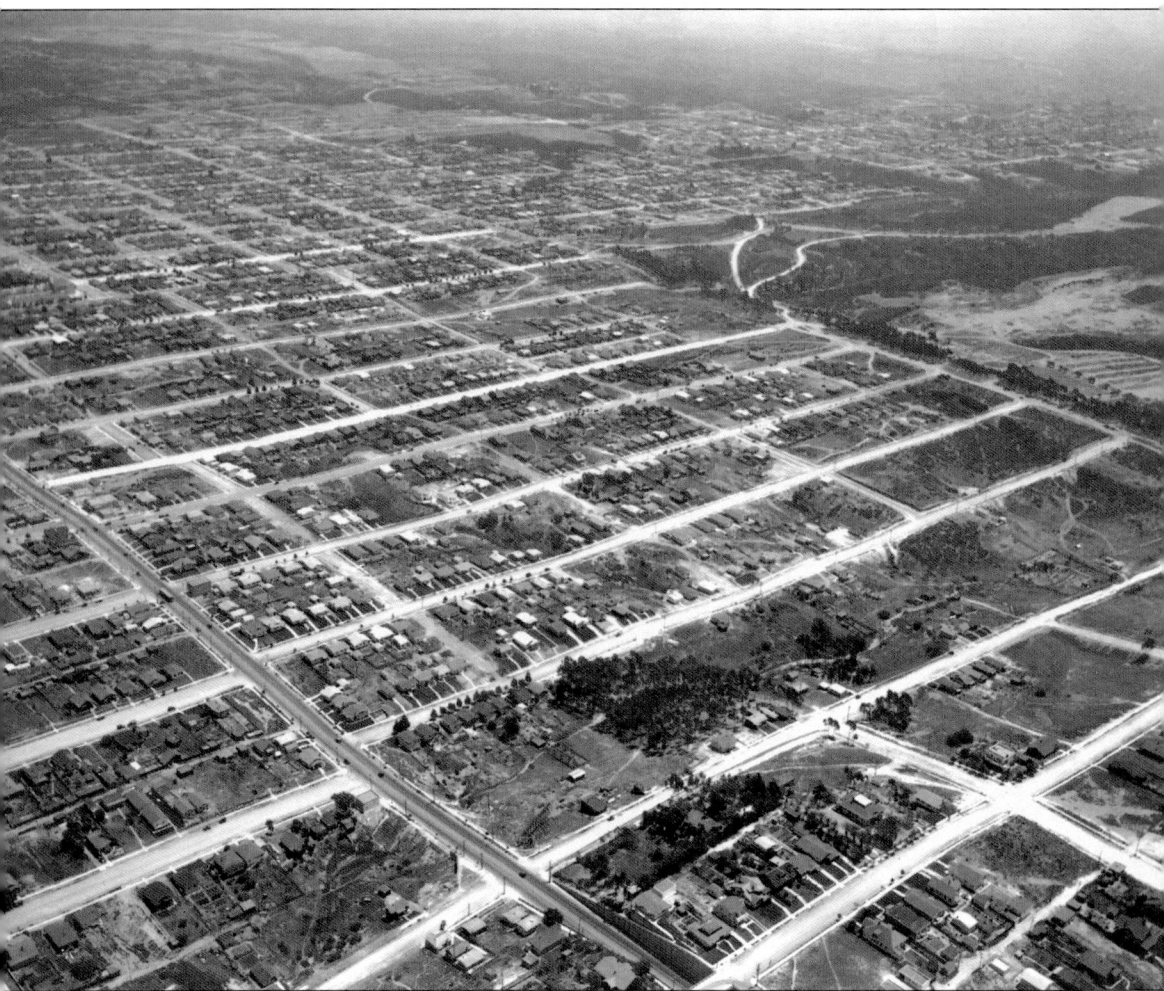

ABOVE NORTH PARK, 1926. The mismatched street grid resulting from North Park's patchwork of subdivision mapping is evident in this aerial view that looks eastward from the Georgia Street Bridge over University Avenue (lower edge). Morley Field (upper right) shows remnants of the 1915 cavalry encampment. The tracts of Pauly's Addition and Park Villas are in the center, with University Heights on the left edge and West End in the distance. (Courtesy of San Diego History Center.)

ON THE COVER: STREETCAR AT THE GEORGIA STREET BRIDGE, 1949. Rumbling west on University Avenue, this streetcar on the No. 7 line has just passed under the Georgia Street Bridge. The initial cut through the hill at this location in 1907 allowed extension of the streetcar eastward from Hillcrest to Fairmont Avenue. With a public transportation system in place, North Park developed from a near-empty mesa to an urban community. (Courtesy of Randy Sappenfield.)

IMAGES of America
SAN DIEGO'S NORTH PARK

North Park Historical Society

Copyright © 2014 by North Park Historical Society
ISBN 978-1-4671-3225-1

Published by Arcadia Publishing
Charleston, South Carolina

Printed in the United States of America

Library of Congress Control Number: 2014933722

For all general information, please contact Arcadia Publishing:
Telephone 843-853-2070
Fax 843-853-0044
E-mail sales@arcadiapublishing.com
For customer service and orders:
Toll-Free 1-888-313-2665

Visit us on the Internet at www.arcadiapublishing.com

Contents

Acknowledgments 6

Introduction 7

1. Early Years 9
2. Building a City of Our Own 21
3. Post–World War II Prosperity Begins 35
4. The Place to Be 47
5. Churches and Schools 61
6. The Toyland Parade 83
7. Changes and Revitalization 93
8. Community Life 107

Acknowledgments

This book represents an all-volunteer effort by members of the North Park Historical Society (www.northparkhistory.org). Those who authored text and obtained photographs include Ed Orozco, Randy Sappenfield, Stephen Hon, Katherine Hon, Valerie Hayken, Jody Surowiec, Sharon Turner, Paul Spears, George Franck, Melanie Gilbert, Louise Russell, Michael Thornhill, and Hilda Yoder. The first six authors listed and Sarah Lara-Toney conducted the formidable task of compiling the book layout. We thank Philip Shirk at Vintage Religion for providing meeting space at his store and Jared Nelson at Arcadia Publishing for providing essential guidance. We appreciate the help of Chris Travers and Jane Kenealy, and especially Carol Myers at the San Diego History Center Research Library. Purchase of San Diego History Center photographs was facilitated by grants from San Diego County Community Enhancement Program, and we sincerely thank county supervisor Ron Roberts for his support. We are grateful to Chris Wray, who generously provided his own historical photographs and assisted us in obtaining others. Those who also contributed their photographs include Michael Good, Donald Madison, Chuck LaBella, Denis Pollak, Roland Blase, Raymond Cooper, Vince Sund, Donna Couchman, Frances Ilig, Charlene Craig, Maria DiGregorio, Joe Schloss, Vicki Granowitz, Ben Press, Vernetta Bergeon, Donald Taylor, Patrick Edwards, Christian Michaels, Paul Body Photography, Larry Hall, Bruce Guy, Stuart Hartley, Japanese American Historical Society of San Diego (through Linda Canada), Hartley family, Stern family, Romano family, Covington family, St. Patrick's Church, Trinity Methodist Church (through Margaret Dick), Plymouth Congregational Church, St. Augustine High School (through Casey Callery), McKinley Elementary School (through Pat Taylor), Lafayette Hotel, North Park Library (through Matthew Nye), San Diego Electric Railway Association, B'Hend and Kaufmann Archives, North Park Lions Club, Bank of America, Merrie Monteagudo, and San Diego Union Tribune/Zuma Press. Unless otherwise noted, all images appear courtesy of the San Diego History Center.

We thank Valerie Hayken Photography & Design (VHPD), a North Park small business, for donating over 200 hours of time scanning and preparing images for publication. Without their expertise, this project would have been considerably more difficult and expensive. VHPD specializes in photo restoration and fine-art landscape photography.

Introduction

Dubbed one of the country's "hippest" places in 2012 by *Forbes Magazine*, North Park fascinates visitors and residents alike with its visible history. Homes built at the beginning of the 20th century shine in Craftsman and Spanish Revival glory. Art Deco and Modernist shop buildings reflect North Park's role as a regional commercial center following World War II. Although the exciting 1950s were followed by decades of decline, North Park is flourishing again.

The story of North Park began in the 1870s, nearly four decades before any urban development. Spurred by the enthusiasm of Alonzo Horton's New Town and dreams of a railroad connection, investors bought land made available by the city government. Two pioneer merchants, Aaron Pauly and Joseph Nash, and the city trustees bought three pueblo lots that encompassed the area between University Avenue and Upas Street and created three subdivisions: Pauly's Addition, Park Villas, and West End. Favoring Horton's Addition downtown, the city trustees disregarded the configuration of the neighboring Park Villas subdivision and provided wider streets, shorter blocks, and six (instead of four) east-west streets for their West End subdivision. Adding to the mismatching, the College Hill Land Association mapped its large University Heights subdivision from University Avenue to the slopes above Mission Valley in 1888 with a street grid that ignored the subdivision mapping to the south. In 1893, James Hartley bought 40 acres in the Park Villas subdivision for a citrus orchard and named his property Hartley's North Park. With its reference to the large City (now Balboa) Park, North Park became a convenient collective name for the entire area. What that area actually encompasses has been the subject of confusion since before 1909, when the *San Diego Daily Transcript* noted in its February 11 issue that "the City Council has as yet been unable to determine the exact boundaries of the North Park Addition." In the 1980s, the City of San Diego defined the Greater North Park Community Planning Area as bounded by the Interstate 805 freeway on the east, Park Boulevard on the west, the hills above Mission Valley on the north, and Juniper Street on the south. This book includes stories and scenes within the community planning area and the Morley Field area of Balboa Park, which has long been considered North Park's backyard.

Through cycles of boom and bust, North Park grew as people with vision and determination invested in infrastructure, homes, and businesses. Three streetcar lines of the San Diego Electric Railway brought people to the nearly empty mesa in the early 1900s. The streetcars ran along Adams Avenue (No. 11), University Avenue (No. 7), and Thirtieth Street (No. 2). Lines No. 7 and 2 resulted in the construction of iconic bridges, one at Georgia Street and the other over Switzer Canyon. The two lines met at University Avenue and Thirtieth Street in 1911 and created the "Busy Corner," then and now the commercial heart of the community.

Another key building block was a reliable water supply. In 1909, an 18-million-gallon concrete reservoir with a wooden roof was completed; it covered the entire block south of Howard Avenue. Achieving adequate water pressure required a raised tank, which was completed in 1910 and served until 1924. That year, the Pittsburgh–Des Moines Steel Company built a 1.2-million-gallon

elevated steel tank. Although it is now empty due to seismic standards implemented in the 1990s, the tank remains North Park's most visible landmark and was listed in the National Register of Historic Places in 2013.

With major infrastructure in place, urban development north and east of Balboa Park began in earnest after 1910. Early craftsmen now recognized by the city as master builders, including David Owen Dryden, designed and constructed homes for their clients and themselves. In 1910, John "Jack" Hartley and his brother-in-law William Stevens subdivided the former citrus orchard of Hartley's North Park into commercial and residential plots. They sold the southern half to energetic developers Joseph McFadden and George Buxton, whose Systems Firm, founded in 1911, only lasted two years but resulted in the distinguished subdivision of Burlingame, now a designated historic district.

The boom in residential and commercial development lasted through the 1920s. Development of the North Park Theatre by Emil Klicka in 1929 was a grand highlight. The elaborate structure housed a performance space for vaudeville and the latest craze, "talking pictures." Although the Depression slowed development, another significant building, the Silver Gate Masonic Temple, was completed in 1932, and a municipal pool opened at Morley Field in January 1933. Recovery and World War II brought another commercial boom that lasted through the 1950s. El Cajon Boulevard saw tremendous growth highlighted by the construction of Imig Manor in 1946, which later became the Lafayette Hotel. Diesel buses replaced the venerable streetcars in 1949, and buildings were modernized to reflect North Park's role as a prime shopping area. The Toyland Parade, started as a Christmas festival by the North Park Businessmen's Association in the 1930s, attracted hundreds of thousands of viewers by the 1950s. Through the years, the parade has featured reindeer, camels, horsemen, grand floats, bands, military tanks, and even a runaway elephant. Hundreds of thousands of spectators also came to the community in June 1963 to see Pres. John F. Kennedy's motorcade along El Cajon Boulevard, creating a lasting memory.

Community improvements after the mid-1960s include the creation of North Park Community Park through demolition of the 18-million-gallon water reservoir in 1967 and removal of power poles along University Avenue by 1971. A horrific community memory resulted from the crash of Pacific Southwest Airlines Flight 182 on September 25, 1978, which killed 144 people. The community is resilient, however. Even decades of commercial disinterest fostered by the rise of regional shopping malls in the 1960s have been reversed. In 2005, the North Park Theatre, which had been vacant for almost 20 years, was restored to its original glory, revitalizing the commercial core. Living in this lively urban village of Craftsman bungalows is appealing once again, and the renaissance continues today.

One

EARLY YEARS

North Park began in the 1870s and 1880s as ink on paper. Prominent entrepreneurs of the day, capitalizing on the dreams of a transcontinental railroad connecting to San Diego, bought large tracts of land and mapped their imaginary subdivisions. The railroad never came, and by 1900, the sagebrush-covered expanse north and east of downtown lay deserted except for small farms and ranches, including the citrus orchard called Hartley's North Park. Drought and economic downturns further dampened confidence. But when the economic panic of 1907 ended, the surge in San Diego's population created a housing shortage. Between 1907 and 1911, extension of streetcar lines along Thirtieth Street and University Avenue provided a reliable public transportation system, transforming North Park into a thriving residential suburb. Real-estate speculators bought up parcels along or within a short walking distance of the streetcar lines and marketed these tracts vigorously. Developers installed the necessary basic infrastructure while the lot's new owner typically hired an architect or craftsman/builder to construct a home. In 1911, the No. 2 streetcar line along Thirtieth Street and the No. 7 line along University Avenue met, and the intersection of Thirtieth Street and University Avenue became the "Busy Corner," a vibrant commercial core. On its northwest corner, Jack Hartley and his brother-in-law William Stevens built North Park's first commercial building in 1913. San Diego's population doubled to 75,000 between 1910 and 1920, and much of the new growth occurred in North Park. Construction slowed when the United States entered World War I in 1917, creating shortages in manpower and materials. However, building renewed as soon as the war was over.

JOSEPH NASH, 1863. The founder of the Park Villas subdivision opened his general merchandise store in Alonzo Horton's New Town of San Diego in 1868. Nash established his subdivision in 1870, although the map was not filed until 1887 due to a legal dispute. Park Villas consists of two large, separate areas between University Avenue and Upas Street—from Arizona to Twenty-eighth Streets and from Ray to Boundary Streets.

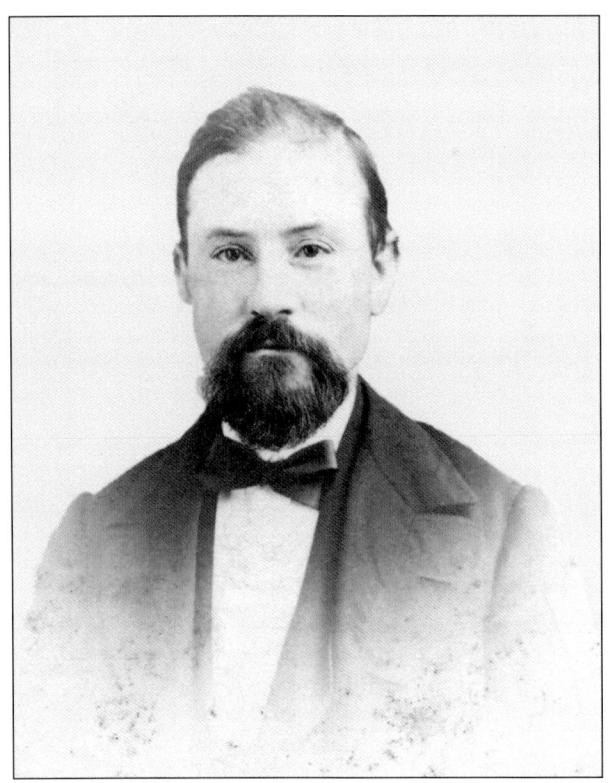

AARON PAULY, 1865. This San Diego pioneer came to New Town in 1869. He established a successful general merchandise store on the wharf and became the first chamber of commerce president. In 1873, Pauly filed the subdivision map for Pauly's Addition, which extends from Alabama to Arizona Streets on the west and east between University Avenue and Upas Street. His son Charles Pauly was a prominent realtor and banker.

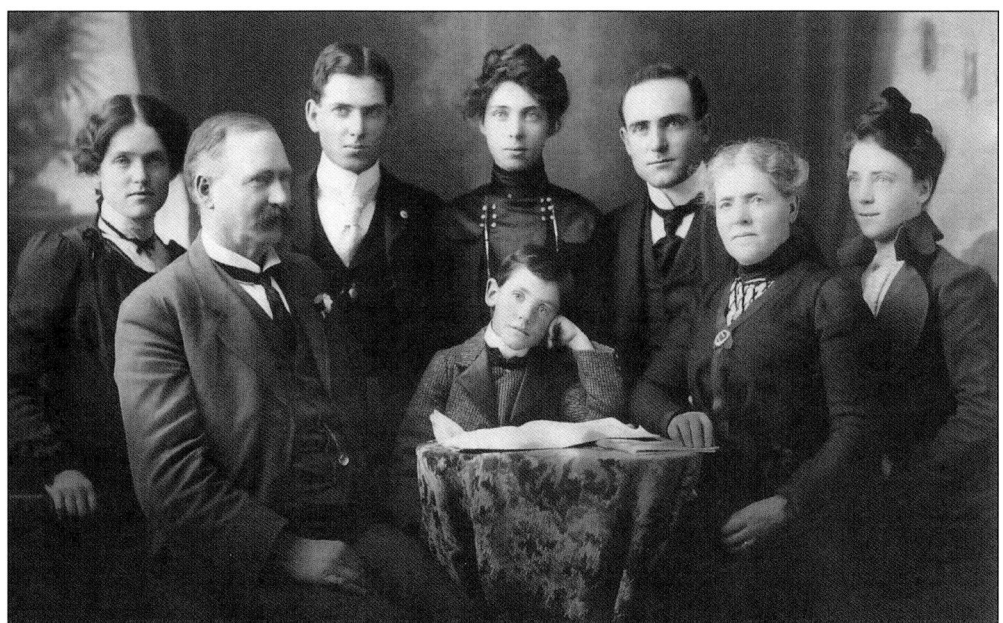

HARTLEY FAMILY, C. 1900. The legacy of North Park's founding family began in 1893 when James Monroe Hartley bought 40 acres of the Park Villas subdivision and named it Hartley's North Park. The land lay between Ray and Thirty-second Streets. Pictured from left to right are (first row) James Monroe, youngest son Paul, and wife Mary Jane; (second row) children Delia, George, Maud, John ("Jack"), and Mary. (Courtesy of the Hartley family.)

PAUL HARTLEY, 1899. Originally from Kansas, the Hartleys moved to their North Park land to establish a citrus orchard in 1896. They lived in a farmhouse at what is now University Avenue and Thirty-first Street. Scarcity of water made citrus farming difficult. In this moment, young Paul Hartley (left) and his friends from the neighboring Stiles family are blissfully unaware of such problems. (Courtesy of the Hartley family.)

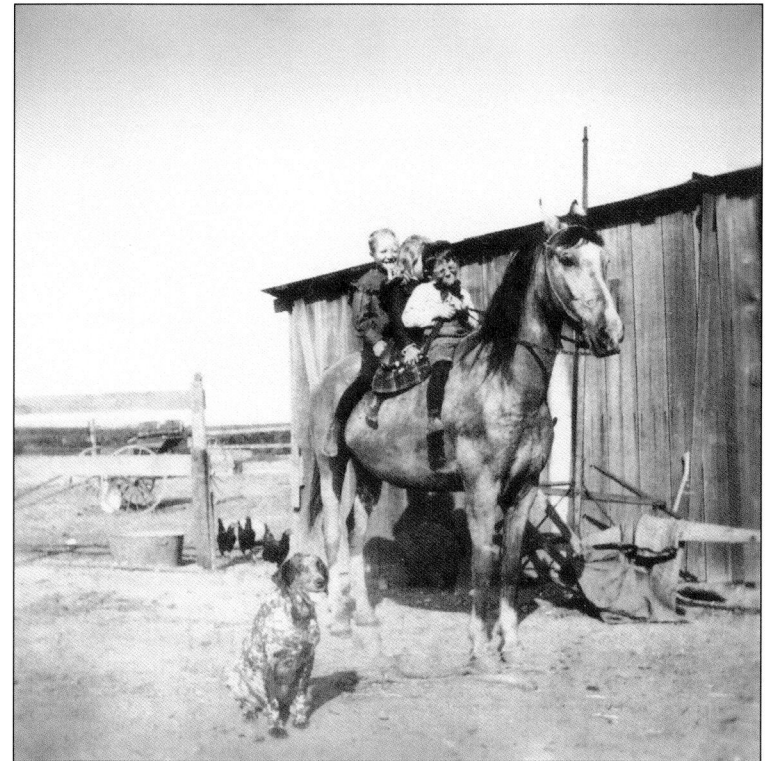

THE RICHARDSON HOUSE, C. 1900. Built in the mid-1890s, this farmhouse was likely moved from the west side of Thirty-first Street to the east side in the 1920s and still stands at 3425 Thirty-first Street. Amos and Lizzie Richardson came to San Diego from New England with their two adult daughters. They were among the seven landowners and 55 residents recorded in the area by the 1900 federal census.

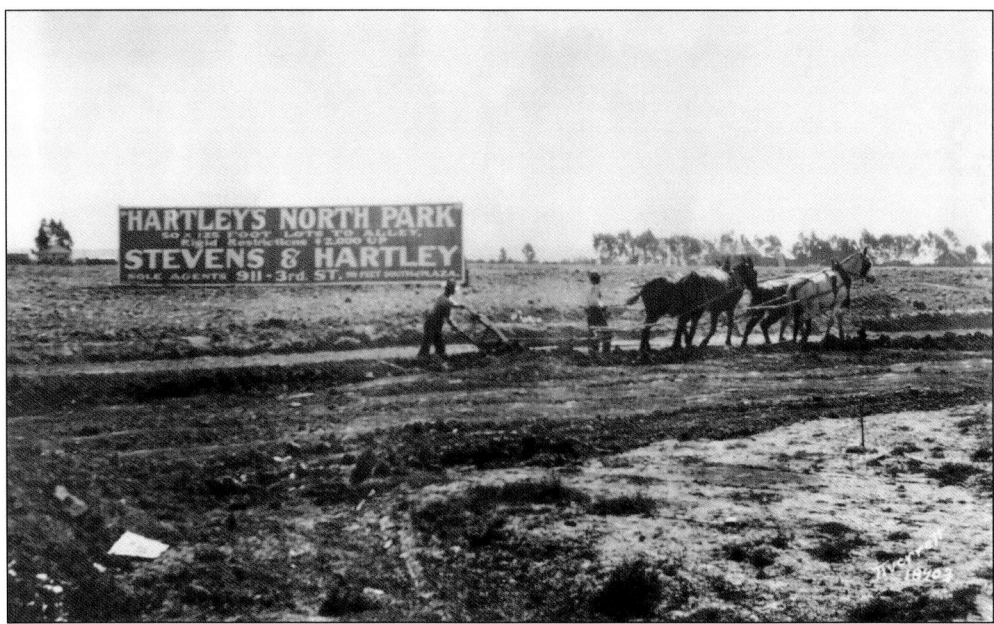

HARTLEY'S NORTH PARK, 1910. The 40 acres that James Monroe Hartley bought in 1893 for a citrus orchard had been fallow since his death in 1904. His eldest son Jack and son-in-law William Stevens led the family in subdividing the land for commercial and residential development, filing their subdivision map on April 8, 1912. They advertised their tract as "the most up-to-date restricted residence district in San Diego."

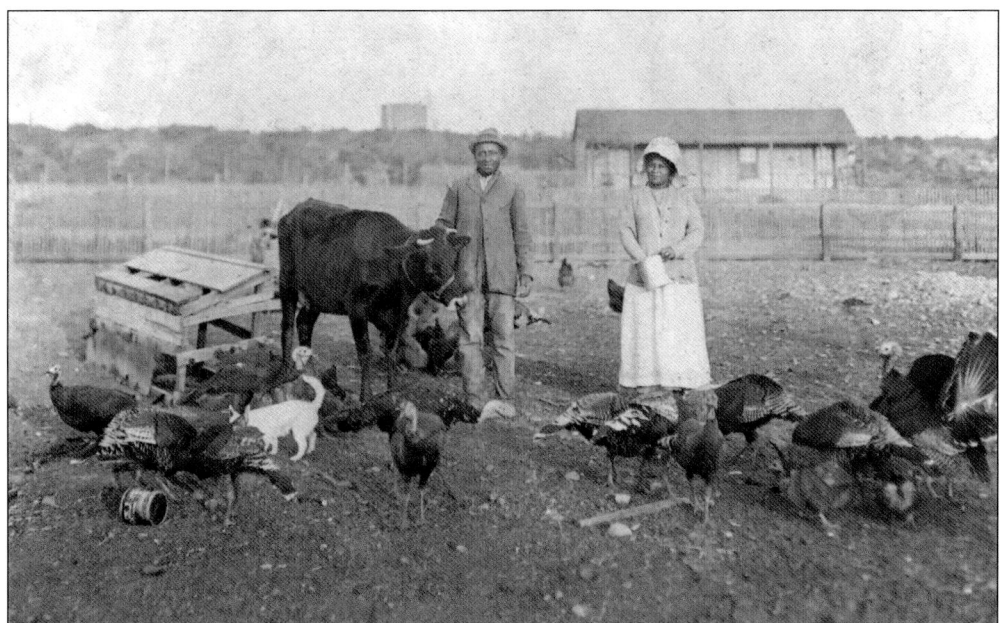

WILLIAM AND ALICE OSBEY, C. 1918. William Homer Osbey and his wife, "Willie" Alice (Goodwin) Osbey, settled at Arizona Street just south of El Cajon Boulevard before 1910. The water tank on Oregon Street is visible in the background. Alice Osbey was part of the large Goodwin family headed by her parents, Jefferson and Sarah Goodwin, who were living nearby at 4329 Oregon Street in 1910.

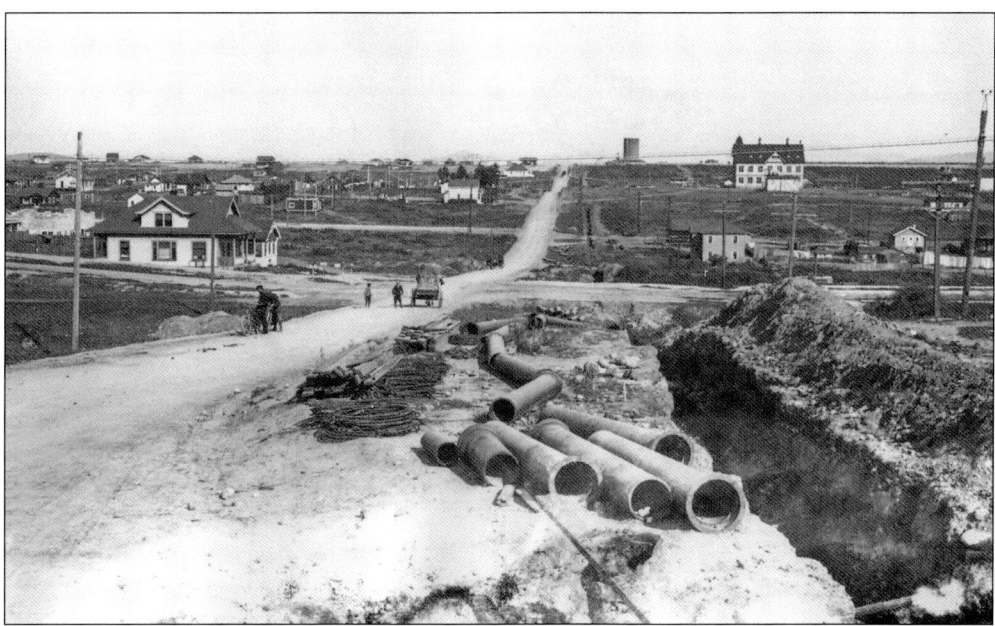

EL CAJON BOULEVARD, 1913. The open trench awaiting new pipeline stretches eastward from Florida Street in the foreground toward the raised water tank at Oregon Street in the distance. The cylindrical water tank was built in 1910. It preceded the elevated tank built in 1924 that is still present. Located on Louisiana Street south of El Cajon Boulevard, Garfield School dominates the sparse development in the University Heights subdivision.

FIRST GEORGIA STREET BRIDGE, 1907. This redwood truss bridge spans the cut that allowed the San Diego Electric Railway No. 7 streetcar line to extend along University Avenue from Hillcrest to Fairmount Avenue. This view is to the east, with Texas Street in the distance. In 1914, double tracks were laid for the streetcar line, and the wooden bridge was replaced by vertical walls and a concrete bridge.

UNIVERSITY AVENUE, 1907. The tracks for the No. 7 streetcar line are under construction in this eastward view from Georgia Street. The large structure on the horizon at Texas Street is Albert and Anna Valentien's pottery factory, designed by Irving Gill. Anna Valentien taught at San Diego Evening High School, where one of her sculpture students was the renowned artist Donal Hord.

14

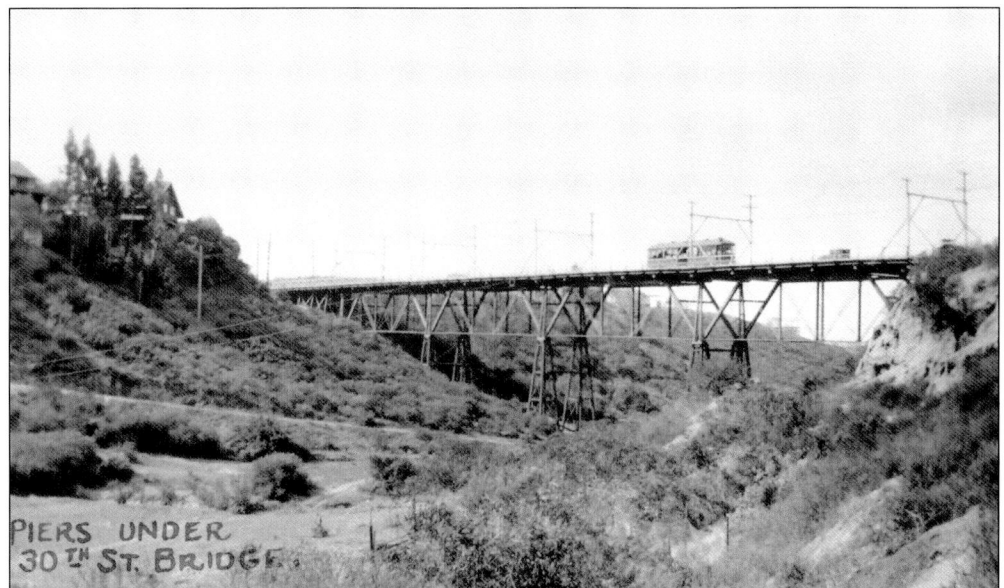

THIRTIETH STREET BRIDGE, 1920. The Cotton Brothers Construction Company completed the Thirtieth Street Bridge in 1908 at a cost of $40,000. The 80-foot-high truss bridge that carried the No. 2 streetcar line and early automobiles spanned 700 feet across Switzer Canyon. Made of steel and concrete with a wooden deck, the bridge linked North Park to downtown San Diego but presented the city with difficult maintenance challenges.

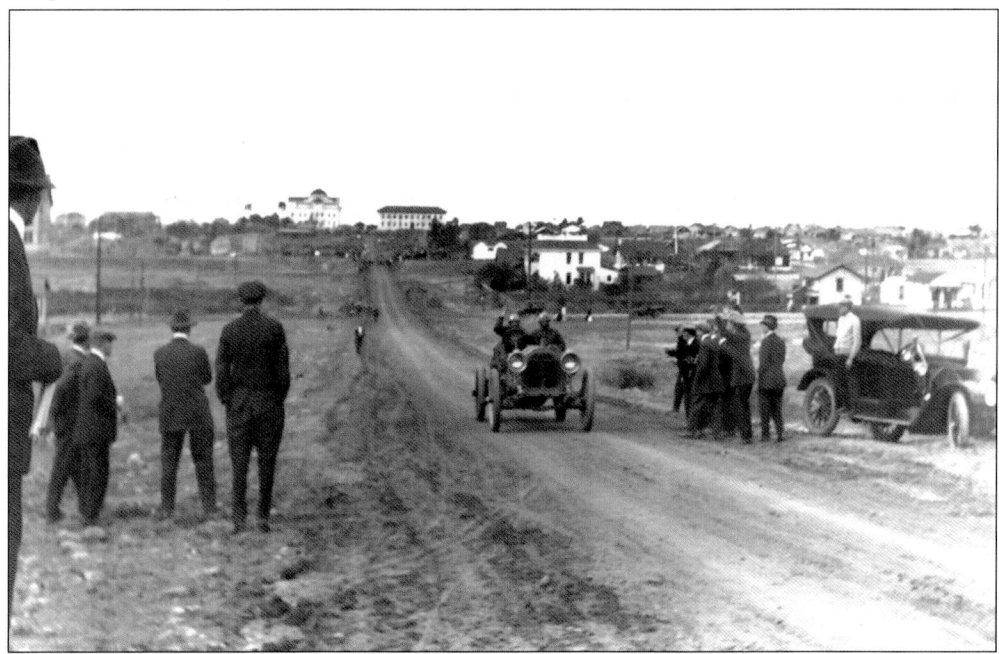

EARLY AUTOMOBILE RACING, 1913. Two buildings of the Normal School are visible on the horizon in this westward view of an early automobile race on the dirt road originally named University Boulevard in the 1888 University Heights subdivision map. Renamed in 1899, El Cajon Avenue (later Boulevard) became the official terminus of Highway 80 when local drivers beat Los Angeles in a race to Phoenix on competing roadways.

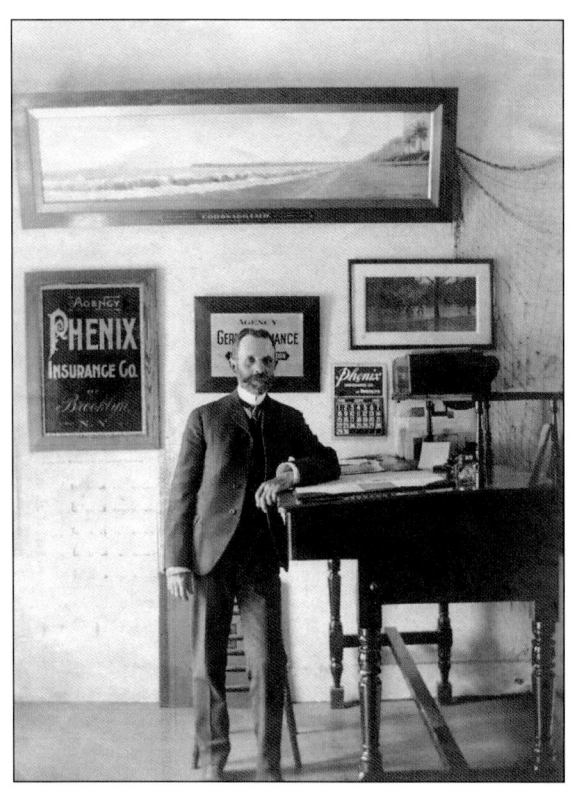

HENRY AND ELLA FOOTE, 1903 AND 1913. The Foote family moved to San Diego in 1897 from Helena, Montana. Pictured at left in his downtown office in 1903, Henry Foote worked as an agent for the New York Life Insurance Company from 1903 to 1910. His wife Ella, pictured below in 1913 at their Utah Street home, led a very active social life into the 1920s. She wrote a series of art columns in the *San Diego Union* and became president of the Wednesday Club in 1913. Founded in 1895, the Wednesday Club has remained one of the most prestigious women's clubs in San Diego. (Both, courtesy of F. Ilig.)

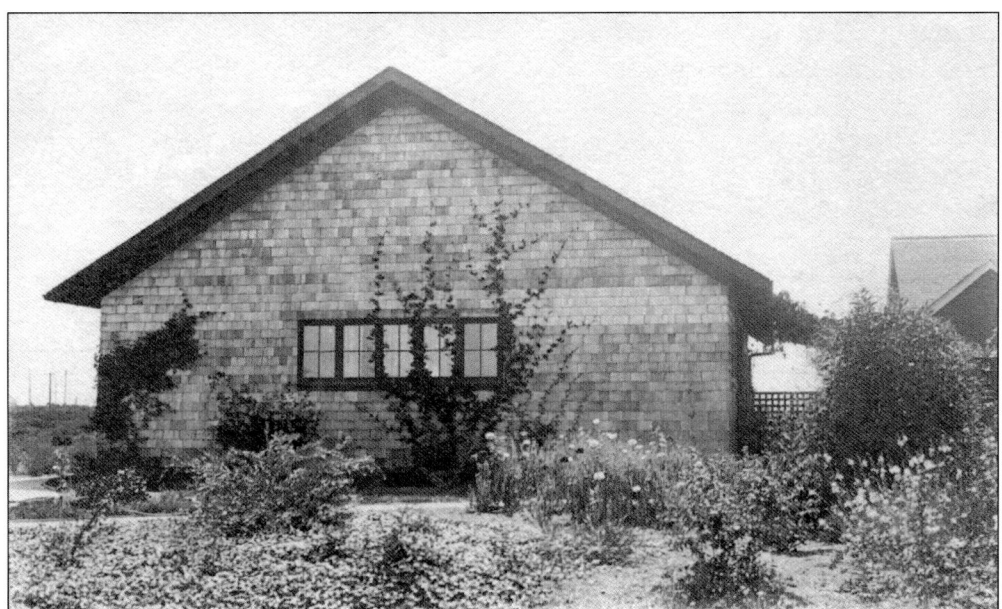

THE COTTAGE, 1909. Henry and Ella Foote purchased a lot in 1908 in the West End subdivision for $150, payable in 12 installments at 14 percent interest. In 1909, Ella Foote obtained the permit to build their home, just the fifth building permit issued for the subdivision. The house on Utah Street became nearly entirely covered with creeping fig until the mid-1970s and still stands today. (Courtesy of F. Ilig.)

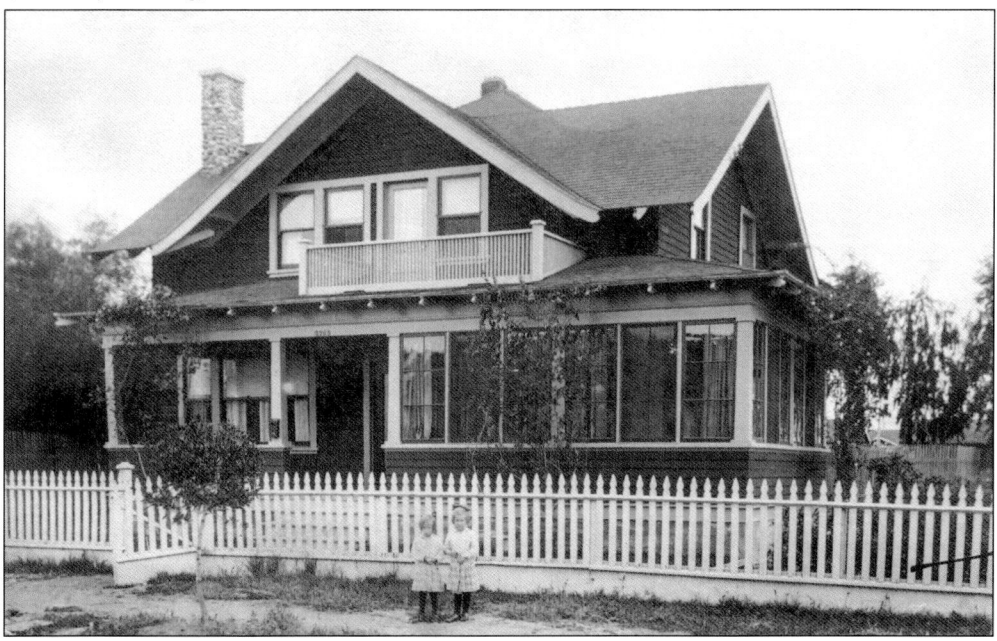

HORTON HOUSE, 1913. In 1908, Frances and Sophia Horton built their home on Utah Street in North Park's West End, where they lived with their five children until 1946. These little girls are twins Myra Ruth and Mable Frieda, who attended Jefferson Elementary, located across the street. They were among the first seventh-grade class at Roosevelt Junior High and graduated from San Diego High School in 1928. (Courtesy of Donna Couchman.)

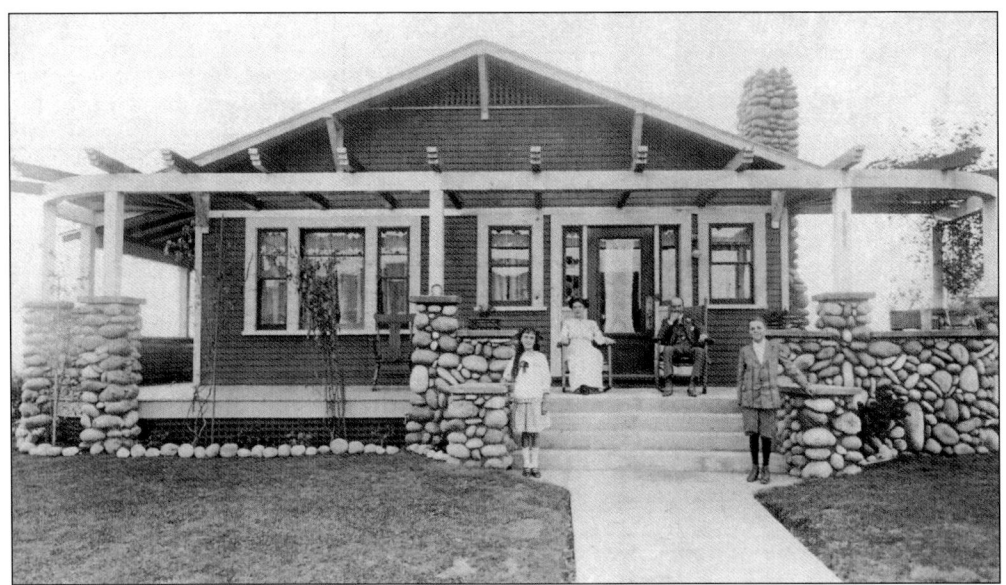

STOCK FAMILY HOME, 1912. Pictured at the southwest corner of Granada Avenue and Thorn Street is the handsome Craftsman bungalow originally belonging to Frederick and Florence Stock, shown with their children Jack and Violet. Though greatly changed in appearance by the removal of the curving pergola porch and most of its distinctive cobblestone masonry, the house remains on Granada Avenue just east of Bird Park. (Courtesy of Michael Good.)

DRYDEN HOUSE, 1916. David Owen Dryden, a master builder in the Craftsman style, built 12 homes along Twenty-eighth Street between 1915 and 1918, including this one, which was initially owned by retired Chicago manufacturer John Carman Thurston. Later the home of North Park historians Donald and Karon Covington, the house is an individually significant designated historical resource and contributor to the North Park Dryden Historic District, established in 2011. (Courtesy of the Covington family.)

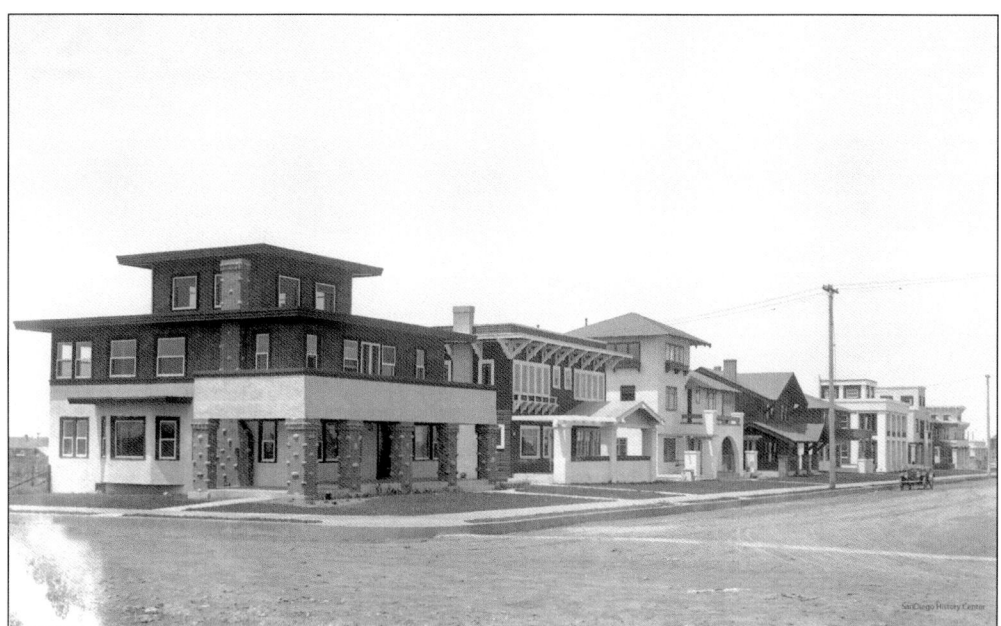

BURLINGAME BEGINS, 1912. Homes are under construction along Kalmia Street (above) and San Marcos Avenue (below) in the historic district of Burlingame, a subdivision marketed as the "Tract of Character" by developers Joseph McFadden and George Buxton and their Systems Firm. The rose-colored sidewalks and streets contoured to canyon topography distinguished the neighborhood of fanciful homes designed by William Wheeler and other prominent architects and builders. Percival Benbough, a successful merchant and future mayor of San Diego, paid $70,000 for nine houses along Kalmia Street in 1913. His extended family, including his widowed mother and three married sisters, more than doubled membership of the Burlingame Club, a women's group that celebrated 100 years of continuous charitable service in 2013. The three houses on the left in the photograph below were designed by Carleton Winslow to suggest an alpine village.

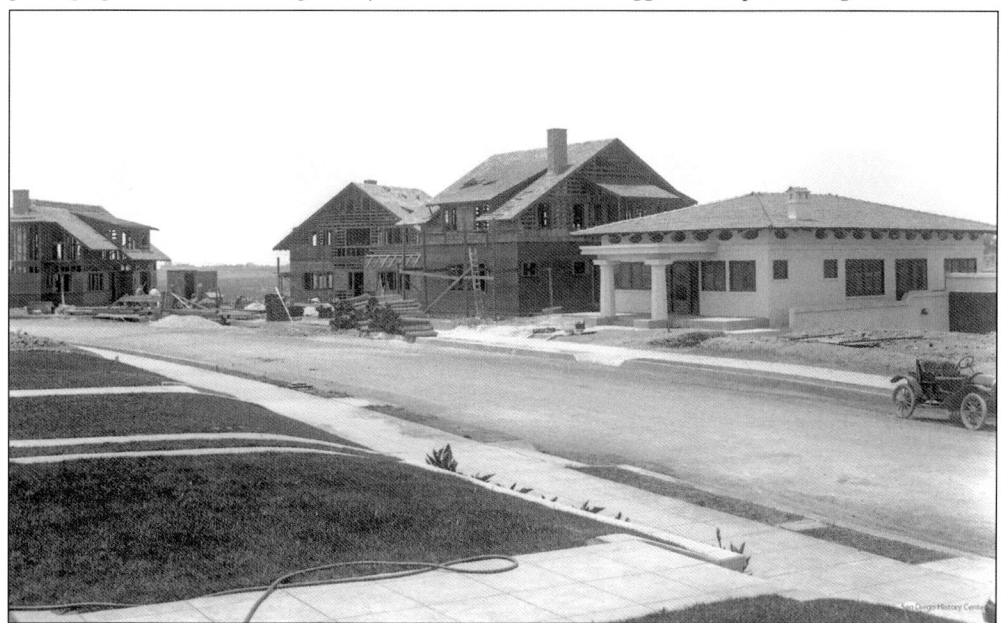

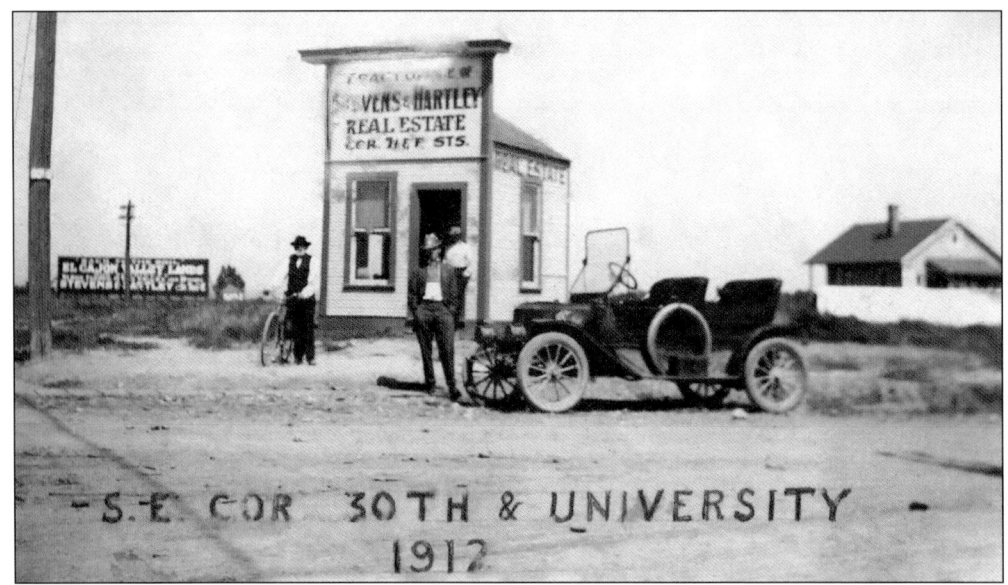

STEVENS AND HARTLEY BUILDINGS, 1912 AND 1919. Jack Hartley and his brother-in-law William Stevens established a real-estate office in downtown San Diego in 1905. They opened a small Stevens and Hartley tract office at Thirtieth Street and University Avenue (above) and built a three-story multi-use structure on the northwest corner in 1913. The building below, which still stands, has housed various pharmacies, a branch post office, and medical and dental offices. In the photograph below from 1919, William Stevens and Jack Hartley are standing in front of their real-estate office in their commercial building. To the right of them is probably the proprietor of the North Park Drug Store, Joseph Hallowell. (Above, courtesy of the Hartley family; below, courtesy of San Diego History Center.)

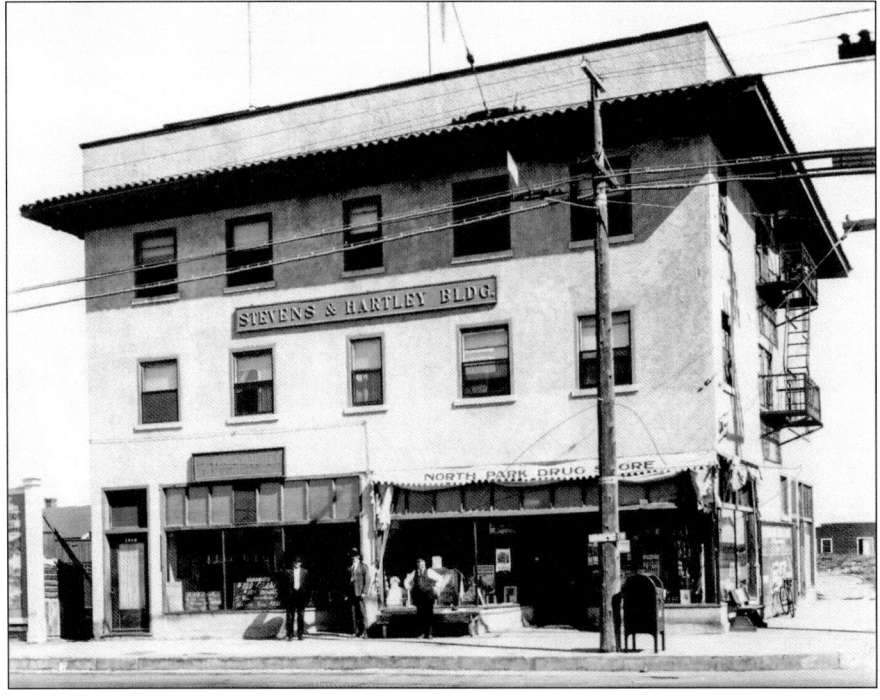

Two

BUILDING A CITY OF OUR OWN

In 1920, prosperity once again came to North Park. A population explosion in 1921 and a severe housing shortage led to the construction boom of 1922 to 1925. To support the increase in population and construction, water, electricity, gas, and streetcar infrastructure were all upgraded. While land along the streetcar lines continued to attract development, ever-rising land costs and the increasing popularity of the automobile convinced investors to redirect their efforts to developing El Cajon Boulevard and new housing tracts in southeastern North Park. Gas stations, restaurants, automobile sales and repairs, and other retail establishments catering to the automobile began to appear on El Cajon Boulevard in the late 1920s. In the meantime, University Avenue became an entertainment, dining, and shopping destination. In 1926, the lighting of University Avenue, North Park's "Great White Way," was celebrated with floats, dancing, and music, with 10,000 people in attendance. In 1928, Emil Klicka, who developed the North Park Theatre, declared, "As to North Park, I believe that within a few years we are going to have a city of our own in this district." Indeed, several thousand residents of the North Park district petitioned the city council for a branch city hall in 1930. With the stock market crash and the onset of the Great Depression, however, that request was denied. Construction slowed and became lackluster until 1935, when the federal government introduced programs for home ownership. Even with the real estate and construction turnaround that year, business remained sluggish until the Great Depression officially ended in 1939. North Park's commercial core thrived once again as retailers catered to locals living in the earlier-developed housing tracts. With the Depression over and San Diego gearing up for the coming war, the population exploded. Between 1941 and 1945, San Diego's population more than doubled to 500,000 inhabitants. Another boom in development commenced. San Diego would never again be the sleepy town it was prior to World War II.

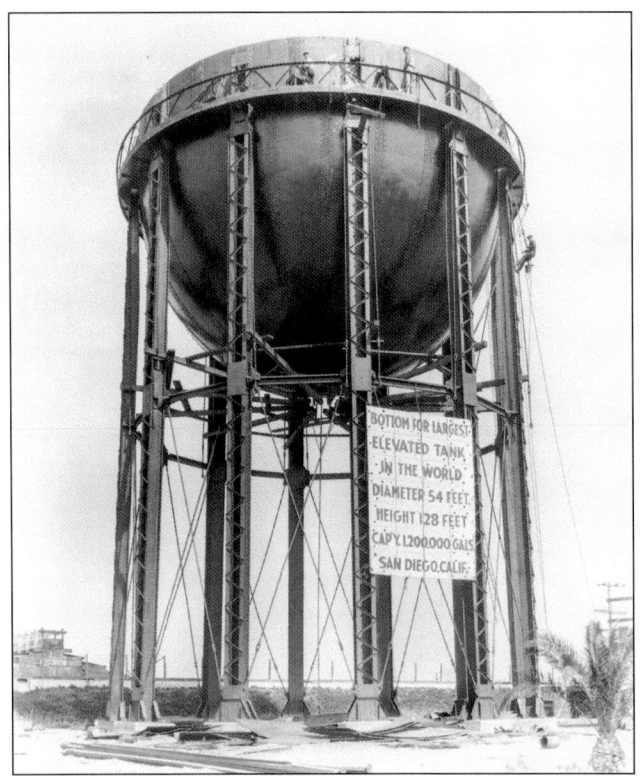

THE WORLD'S LARGEST ELEVATED TANK, 1924. Water pressure became a problem in the 1920s because of the rapidly growing population on the mesa north of Balboa Park. In 1923, a municipal bond election funded a new water tank to hold 1.2 million gallons. As indicated by the sign, the tank was believed to be the largest elevated tank in the world. Water treatment facilities can be seen to the left.

NORTH PARK'S WATER TOWER, 1925. Just south of El Cajon Boulevard between Oregon and Idaho Streets, the water tower remains one of San Diego's most visible and recognizable landmarks, as well as a symbol of the North Park area. The Pittsburgh–Des Moines Steel Company built the tower. The structure and the surrounding area were listed in the National Register of Historic Places as a historic district in 2013.

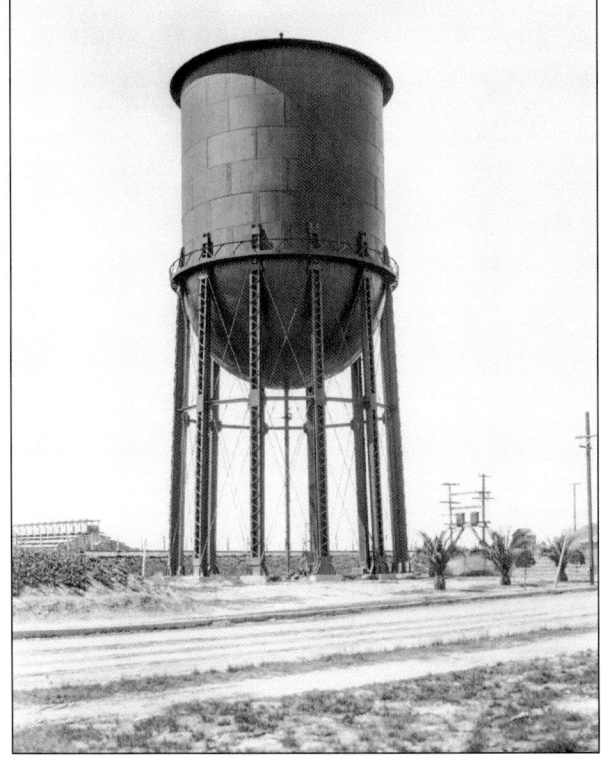

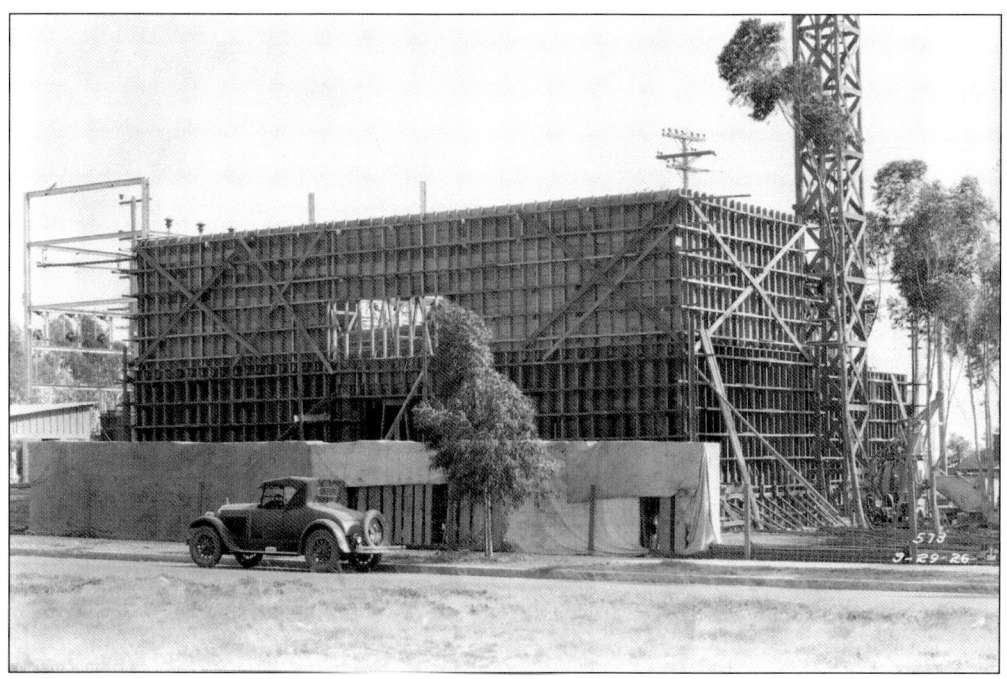

ELECTRIC SUBSTATION F, 1926. On April 15, 1926, a building permit was issued to the San Diego Consolidated Gas and Electric Company (now SDG&E) for a tile and stucco substation at 3169 El Cajon Boulevard between Iowa and Boundary Streets. Construction cost was estimated at $38,000. In those days, the northeast section of the city, including North Park, placed a great demand on the company. Therefore, plans were made in 1925 to build a substation to serve these growing neighborhoods. The formally balanced two-story building was modeled in the style of a Spanish Renaissance villa to blend in with the neighborhood. Busts of Thomas Edison and Benjamin Franklin were chosen by the local residents to adorn the facade. (Above, courtesy of the Covington family; below, courtesy of the San Diego History Center.)

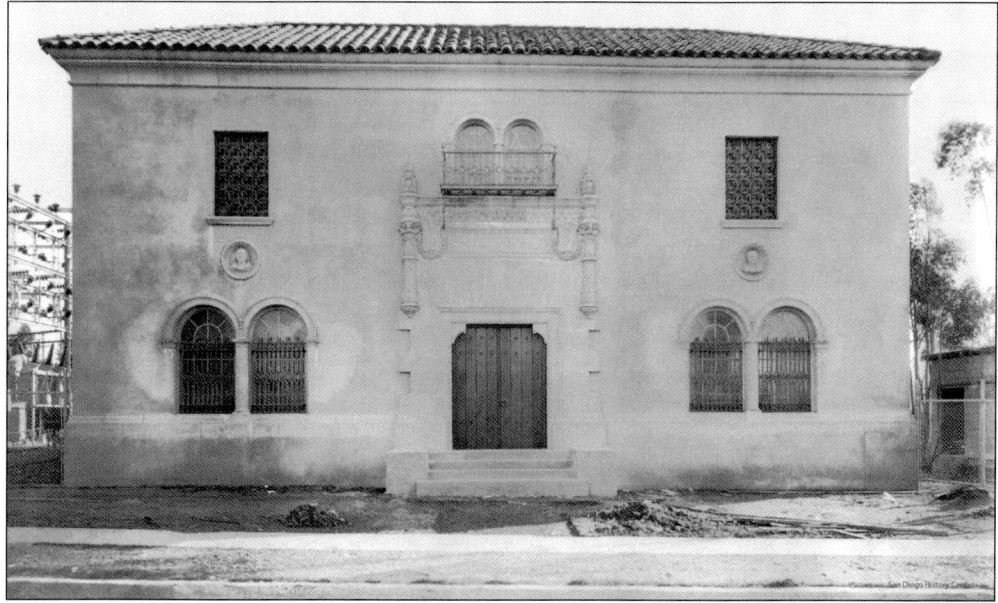

GEORGIA STREET BRIDGE, 1929. When University Avenue needed to be widened to accommodate double tracks for the No. 7 streetcar line in 1914, city engineer J.R. Comly chose the aesthetics of the City Beautiful movement for the concrete-arch replacement bridge and supporting vertical walls. The bridge celebrated its 100th birthday in 2014.

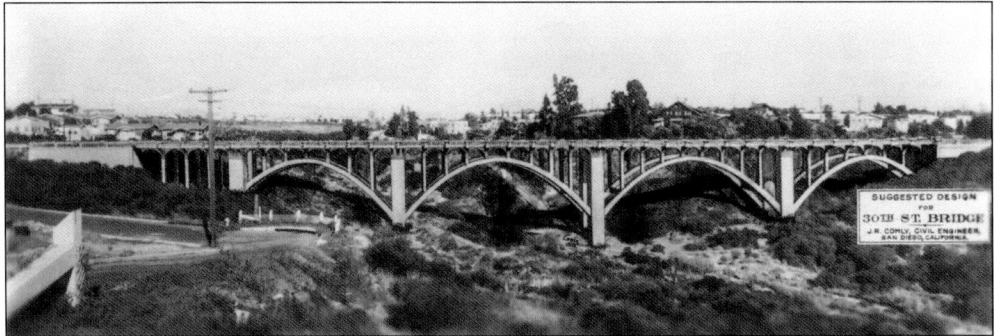

THIRTIETH STREET BRIDGE SKETCH, 1931. The Thirtieth Street Bridge over Switzer Canyon was a challenge to maintain. Its wood decking had been replaced repeatedly due to heavy traffic and deck fires from matches and cigarettes dropped from automobiles and streetcars. J.R. Comly proposed this elaborate concrete-arch replacement bridge in 1931. The $275,000 estimated cost once again led the city to appropriate $1,000 to repair the existing bridge.

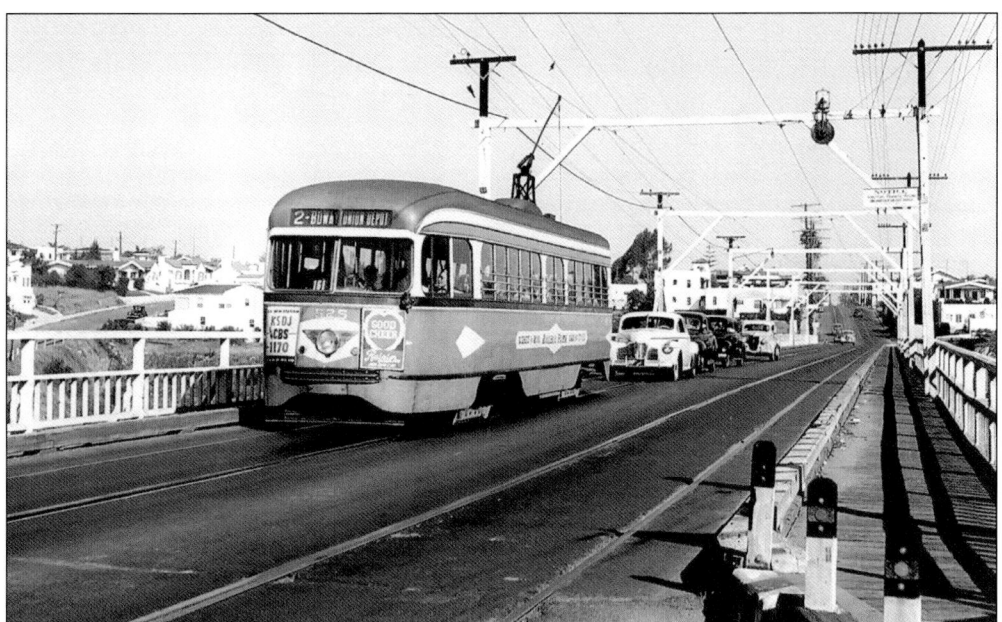

PCC Streetcar, 1940s. Presidents Conference Council (PCC) Streetcar 525 on the No. 2 line travels southward on the Thirtieth Street Bridge over Switzer Canyon. These single-end streamlined streetcars were introduced in 1936–1937. The modern streetcar, the result of a committee formed in 1929, was designed to be quieter and more comfortable. (Courtesy of San Diego Electric Railway Association.)

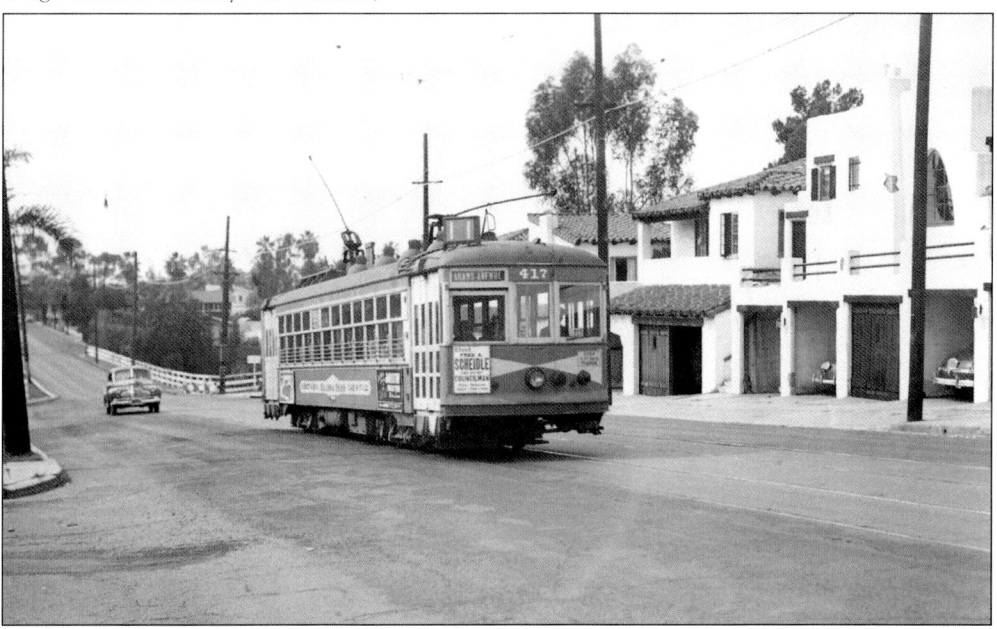

Streetcar on Adams Avenue, 1949. In 1923–1924, fifty Class 5 streetcars, numbered 400 through 449, were purchased for John D. Spreckels's San Diego Electric Railway system. Streetcar 417 on the No. 11 line travels eastward from the brick carbarn located at Adams Avenue and Florida Street. Completed in 1913, the barn was demolished in 1979, and the area became Trolley Barn Park in 1991. (Courtesy of Larry Hall.)

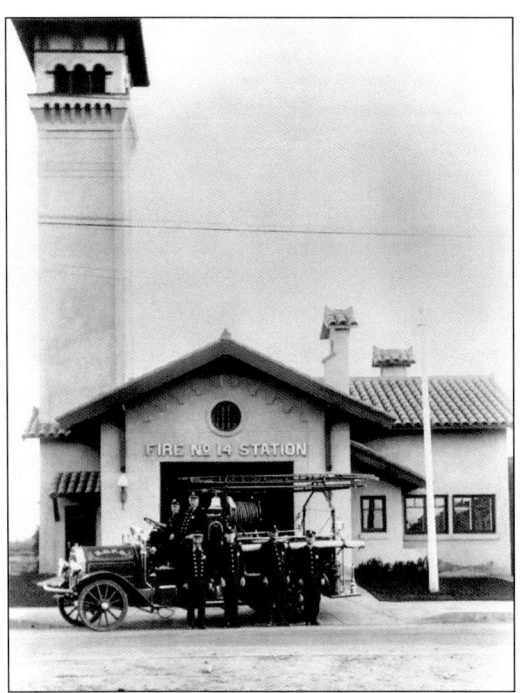

SAN DIEGO FIRE STATION 14, 1925. This Spanish Revival–style building was constructed on the south side of University Avenue between Grim Avenue and Ray Street on land donated by Mary Jane Hartley. Its landmark lofty tower was functional as well as decorative, providing an ideal place for drying the heavy fabric fire hoses after use. The fire company was relocated to Thirty-second Street at Lincoln Avenue in the 1940s.

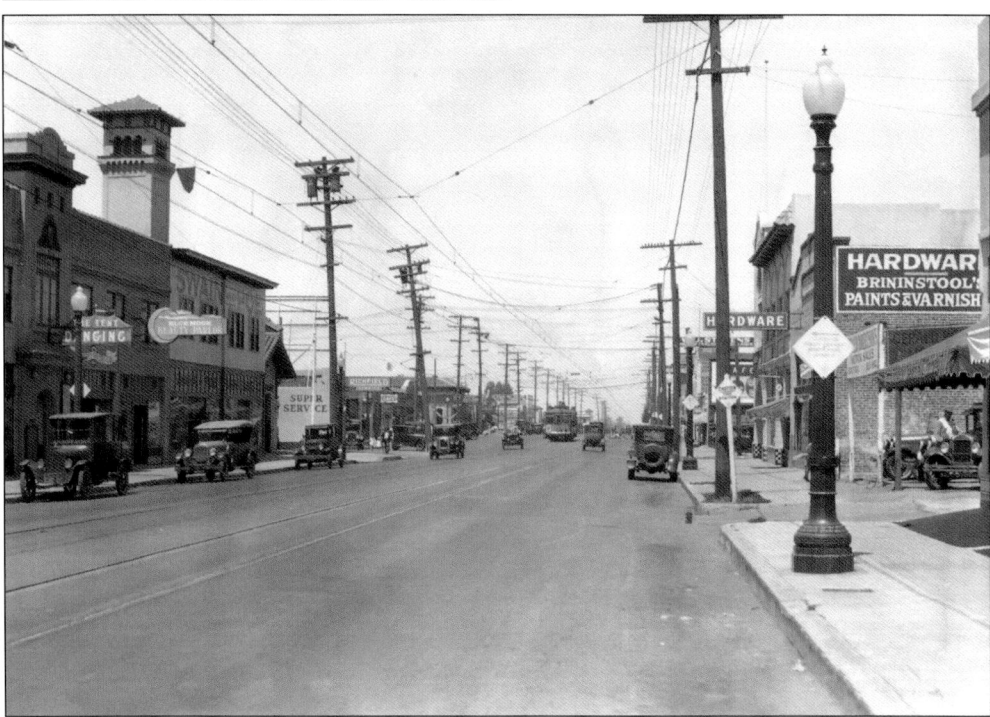

THE "TENT" BUILDING, 1928. As seen from the north side of University Avenue at Grim Avenue, the Nordberg, or "Tent," building occupied the intersection's southwest corner. During the 1920s, the Tent was a neighborhood dance hall located above a commercial storefront. The recently renovated building was once home to Thrifty Drug Store and most recently has served as a fitness center. The fire station tower can be seen on the left.

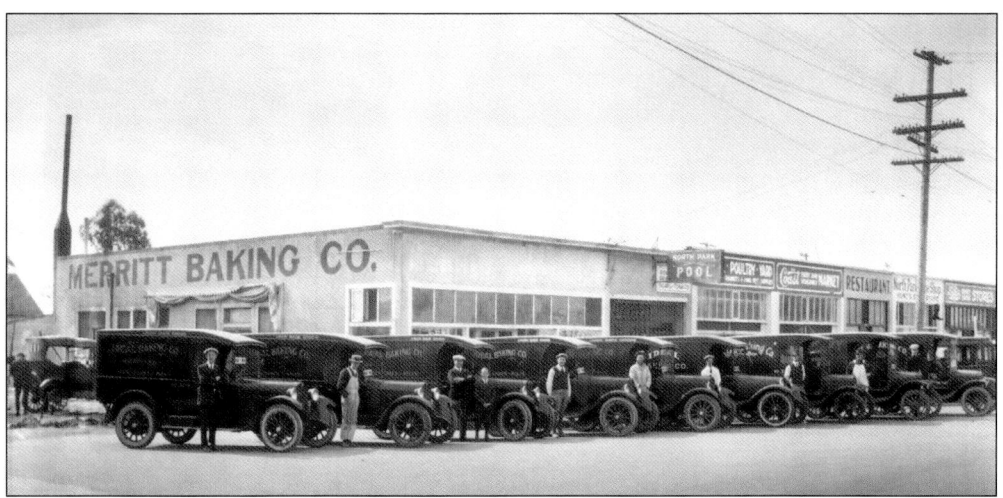

HARTLEY ROW, 1923. Located on the south side of University Avenue at the southwest corner of Ray Street, this commercial building once housed the Merritt Baking Company, whose row of up-to-date delivery vans line the street in this photograph. The Schloss family's A and B Sporting Goods has occupied the building's corner position for decades, and tenants to the west have included restaurants, jewelers, shoe stores, and clothiers.

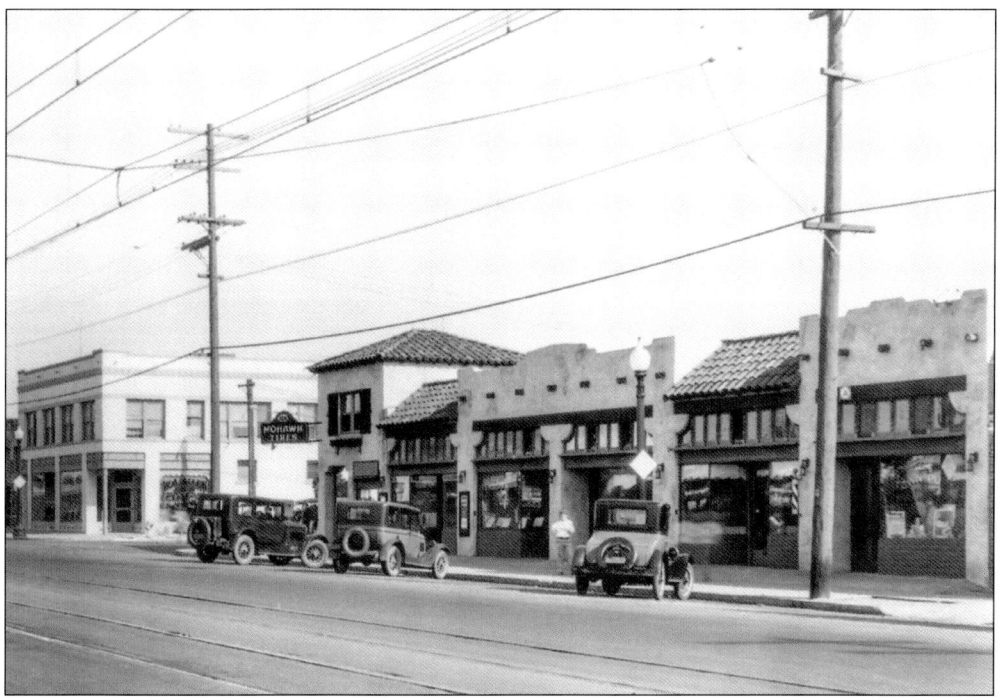

UNIVERSITY AVENUE, 1922. The handsome white brick and tile Granada Building, as seen in the distance on the southeast corner of University and Granada Avenues, has remained one of North Park's least-changed commercial buildings during its nine decades. The Spanish Colonial and Pueblo-style buildings in the foreground were completely remodeled long ago to a nondescript uniform facade.

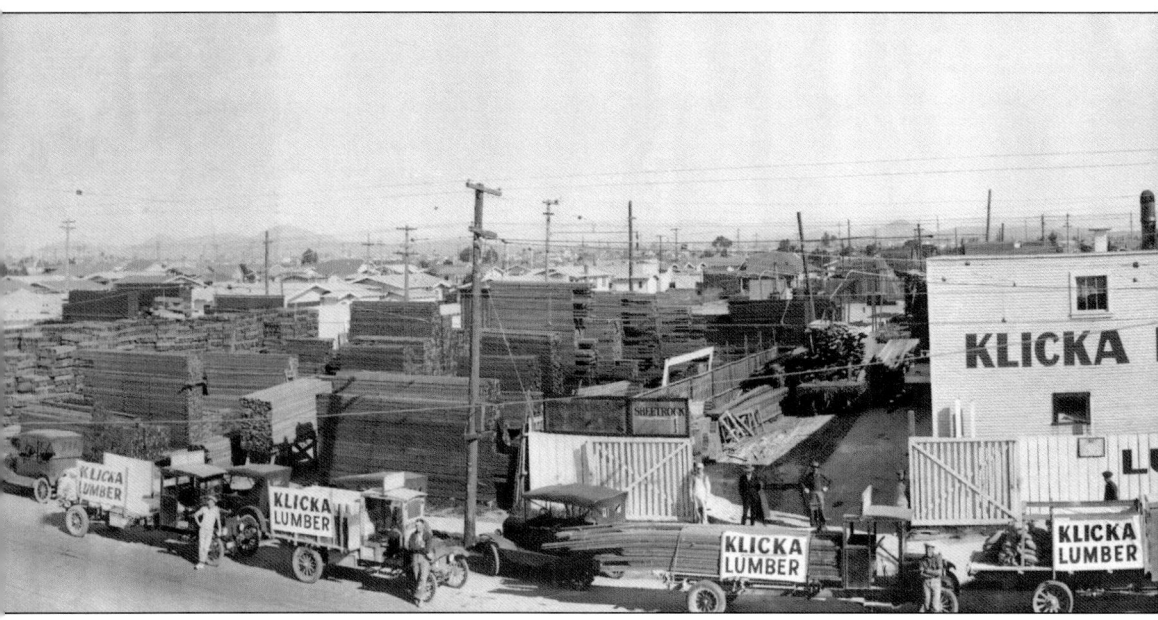

KLICKA LUMBERYARD, 1926. Emil and George Klicka were brothers whose family owned a wood-products company in Chicago. They moved to San Diego in 1921 and settled in North Park. In 1922, they opened a large lumberyard in the 3900 block of Thirtieth Street. The Klicka Lumber Company and the Dixie Lumber Company (forerunner of Dixieline) on Ohio Street supplied much of the lumber for the new streetcar suburbs. The Klickas' business interests included the

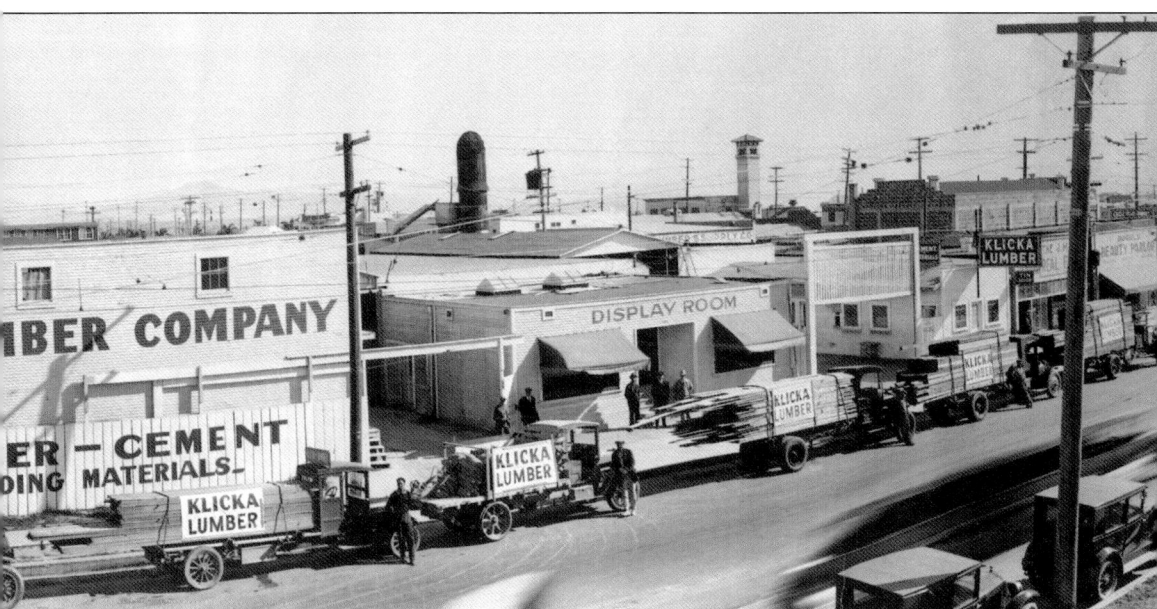

building of the North Park Theatre and publishing of the first *North Park News*. George Klicka developed a kit home in the 1930s, and more than 2,000 were sold throughout San Diego. The Klicka lumberyard closed in the late 1940s and was the site of a Mayfair Market. The site is now the location of La Boheme condominiums. (Courtesy of the Covington family.)

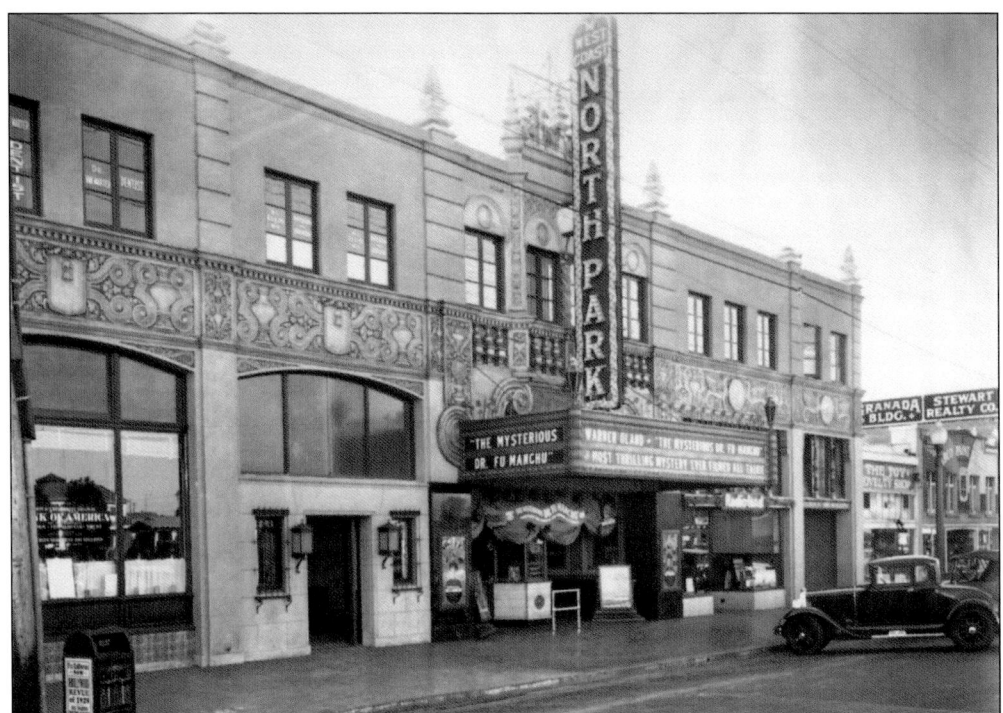

NORTH PARK THEATRE, 1930 AND 1932. The North Park Theatre and Klicka Building opened as the jewel of the community's commercial center in 1929. Originally part of the chain of Fox West Coast theaters, it was the first theater in San Diego built to show the latest craze, "talking pictures." The theater, also built for vaudeville performances, has a proscenium arch stage and full-sized orchestra pit. Funded by Emil Klicka at an expected cost of $350,000, the building's design featured a Spanish Renaissance facade with prominent arabesque friezes. The building also housed the Bank of America, shops, and medical offices. It hosted food drives for the community during the Depression (below). The bank remained in the building until 1950. After the theater closed in 1975, the building operated as a church and was then vacant for years before being restored in 2005. (Both, courtesy of B'hend and Kaufmann Archives.)

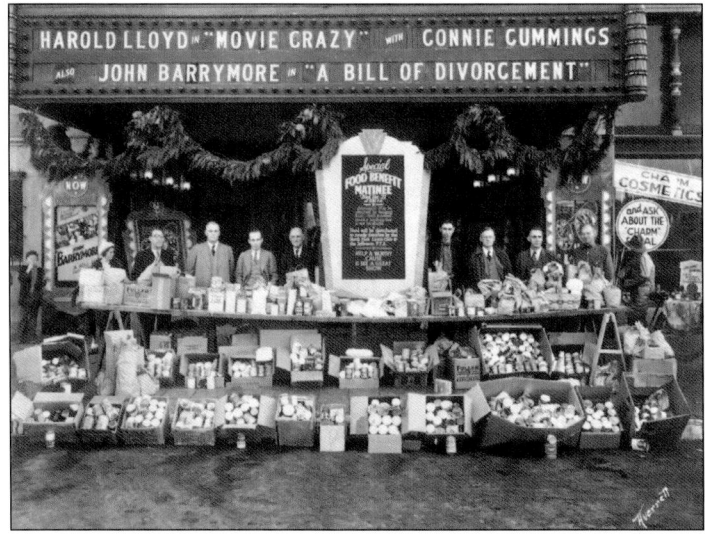

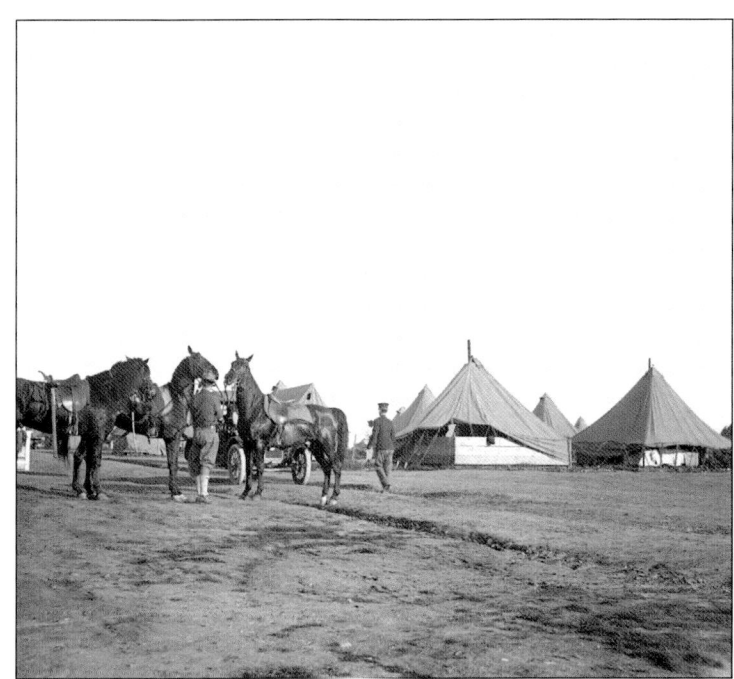

CAVALRY ENCAMPMENT AT MORLEY FIELD, 1915. In order to alleviate any concerns related to the 1914 Mexican Revolution, military units were stationed on the grounds of the 1915–1916 Panama California Exposition. A US Army cavalry unit was stationed at Morley Field. The cavalry also took part in parades and ceremonies. The camp was later removed, and John Nolen created the first city plan for the Morley Field area in the 1920s.

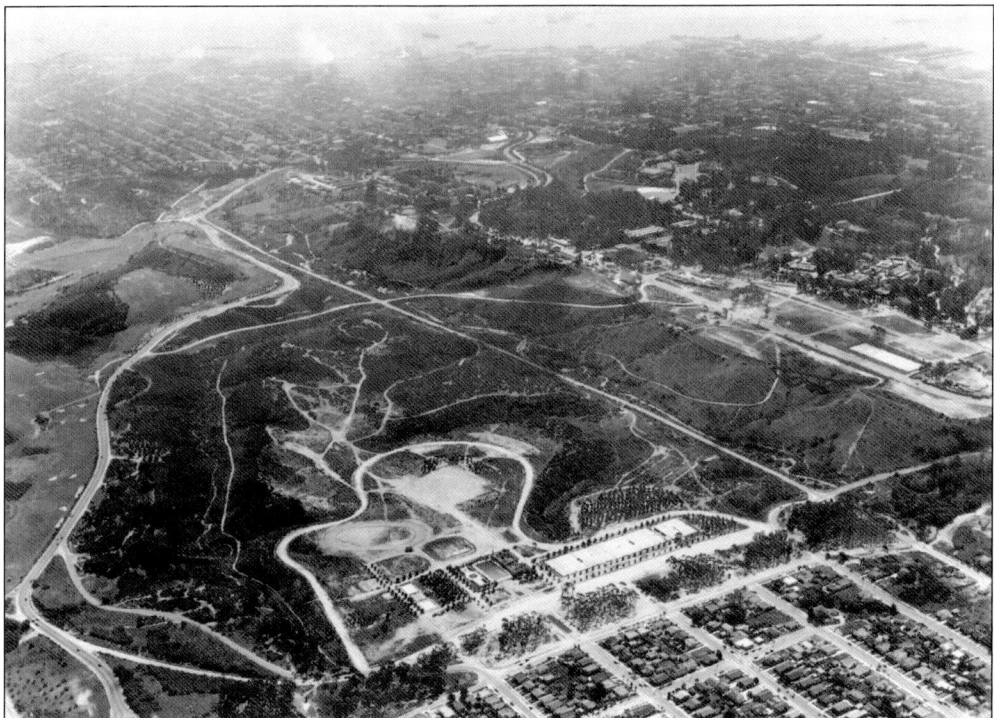

MORLEY FIELD AERIAL VIEW, MID-1930S. This photograph of Morley Field was taken after the 1935–1936 exposition. In addition to the 10 original tennis courts, the municipal swimming pool and clubhouse, baseball and softball fields, and the original dirt velodrome (bicycle track) are also visible. The Arizona Street Canyon is in the center of the photograph, which shows the topography prior to the landfill that began operating in 1952.

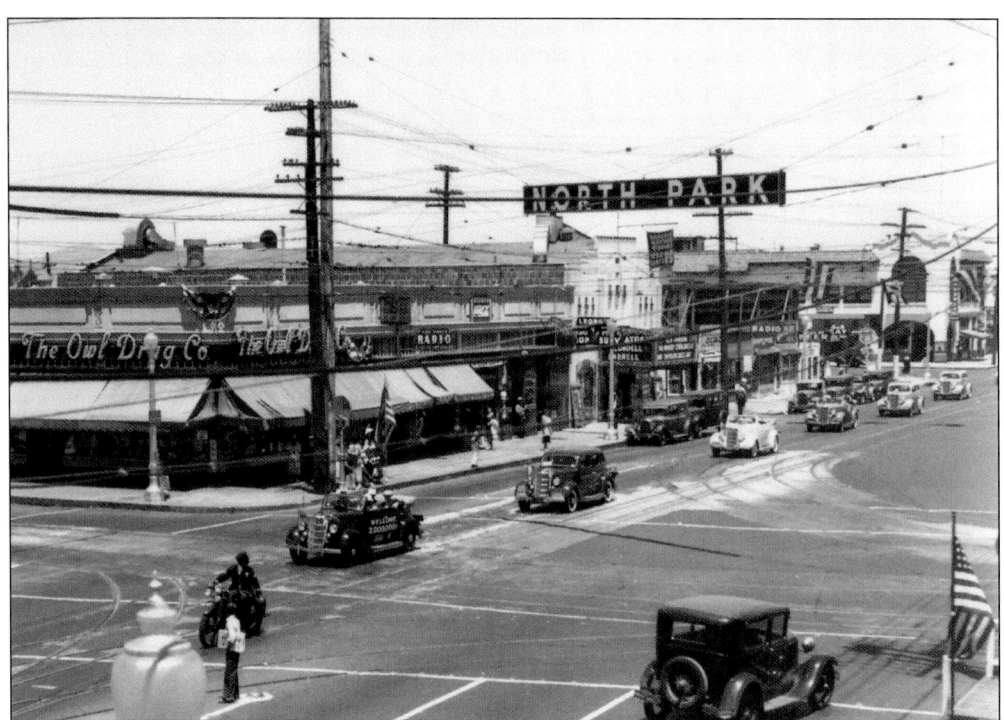

ORIGINAL NORTH PARK SIGN, 1935. The Ford motorcade enters the intersection of Thirtieth Street and University Avenue on its way westward to the grounds of the California Pacific International Exposition in Balboa Park, passing the Owl Drug Company building and Ramona Theatre on July 6, 1935. A special city ordinance allowed the North Park sign to be hung above the intersection. The sign had been installed that very morning.

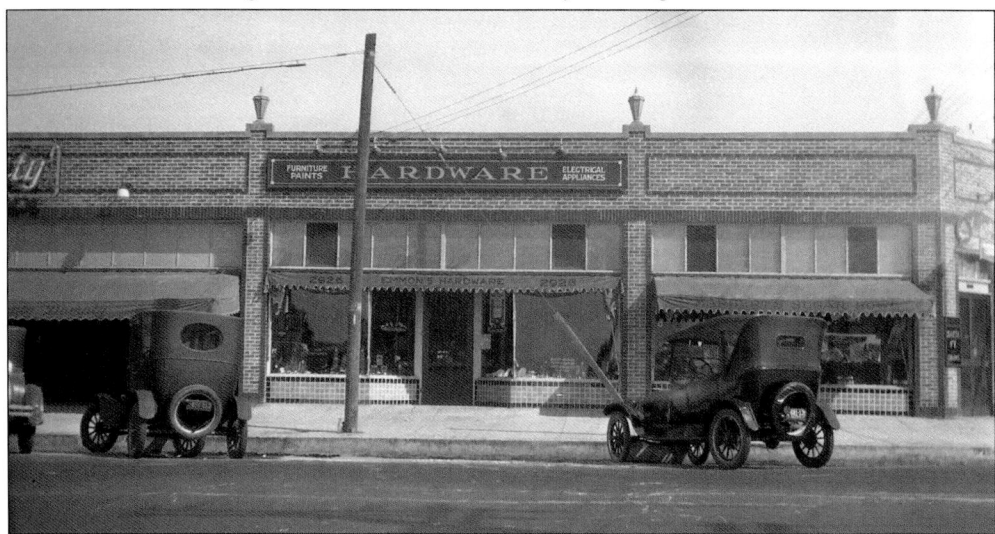

EMMONS FAMILY HARDWARE STORE, 1927. This single-story brick commercial building is pictured at the northwest corner of Thirtieth and Upas Streets. In addition to the hardware store of Arthur and Rolene Emmons, the building's tenants then included a grocery and a drug store. Though substantially remodeled, the building remains. The corner portion has served as a neighborhood bar for many years, most recently as the Bluefoot. (Courtesy of Charlene Craig.)

32

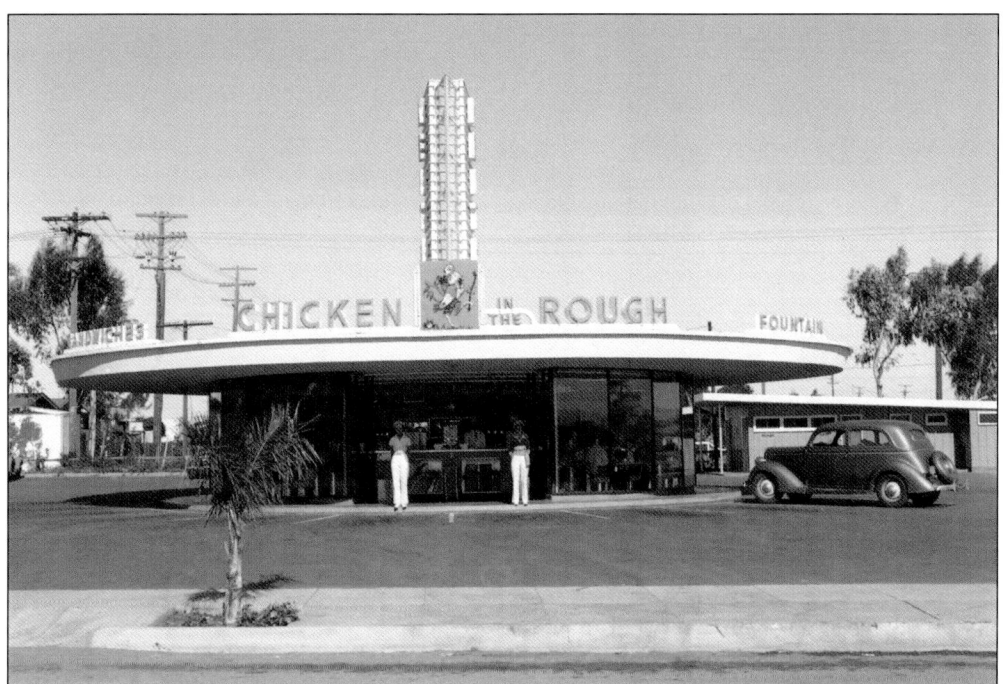

KEITH'S CHICKEN IN THE ROUGH, 1939. In the 1930s, several restaurants opened along El Cajon Boulevard in a new format—the drive-in, where waitresses would bring food to patron's cars. Keith's at Thirty-second Street was the longest running drive-in until demolished for the Interstate 805 freeway in the 1970s. The neon sign had a chicken dressed in golf clothes holding a club, with a golf ball behind him in the grass.

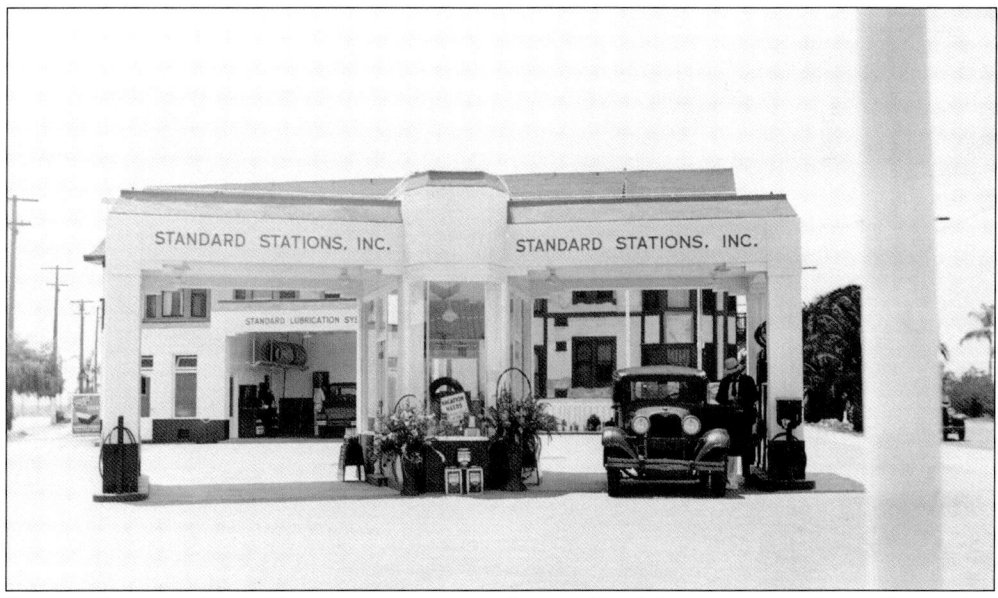

SERVICE CENTER, 1934. The service center in the middle of the pump island is visible in this close-up of the Standard (now Chevron) gas station at the corner of Park Boulevard and Normal Street. As with many other gas stations, the concept of service has changed along with the architecture. (Courtesy of Denis Pollak.)

SILVER GATE MASONIC TEMPLE AND GROUNDBREAKING, 1931. In 1930, the Quayle brothers, who had previously designed the North Park Theatre, were hired to design a major Masonic temple for the Silver Gate Masonic Lodge at the corner of Wightman and Utah Streets in the commercial district. Edward Fletcher, of the prominent Fletcher family, directed the campaign to raise $75,000. The photograph below shows the Masons at the groundbreaking ceremony in April 1931. The Masons are wearing the traditional Masonic apron, a symbol of honor. Fletcher is the tall person in the center of the second row. The building was completed on December 2, 1931. The Quayle brothers designed the temple to be a blend of a Mesopotamian ziggurat and an Egyptian temple, which were features found in the popular Art Deco style of the 1920s to the 1940s.

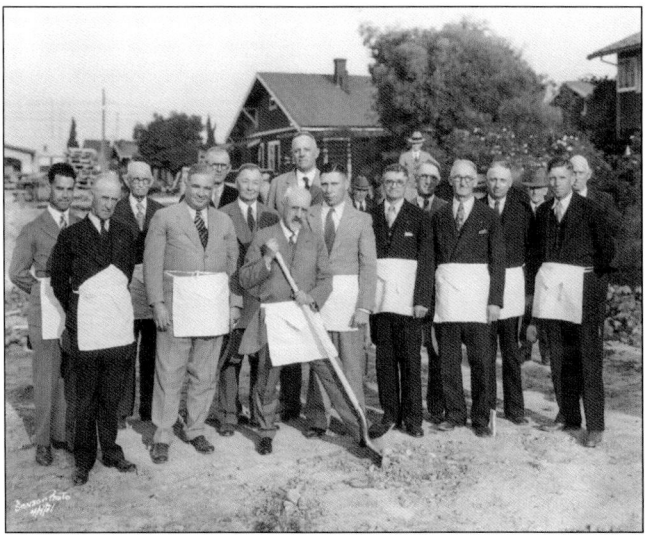

Three
Post–World War II Prosperity Begins

World War II brought major changes to San Diego. The city became a hub of the war effort, initiating the growth of the aerospace industry. The completion of the San Diego Aqueduct in 1947 brought Colorado River water to a parched county that had lacked a reliable water supply. The population of the city increased by over 50 percent between 1940 and 1950. North Park was ideally situated to share in the postwar prosperity, with its central location and established commercial districts. El Cajon Boulevard saw tremendous growth highlighted by the construction of Imig Manor in 1946, which later became the Lafayette Hotel. Retail stores—including national chains such as J.C. Penney, Woolworth, and Pep Boys—and teen-friendly activities, such as roller-skating at the Palisade Gardens rink, flourished along University Avenue. Mayfair Market replaced the Klicka lumberyard on Thirtieth Street. As the 1950s dawned, buses replaced the venerable streetcars, and buildings were modernized to reflect North Park's role as a prime shopping area.

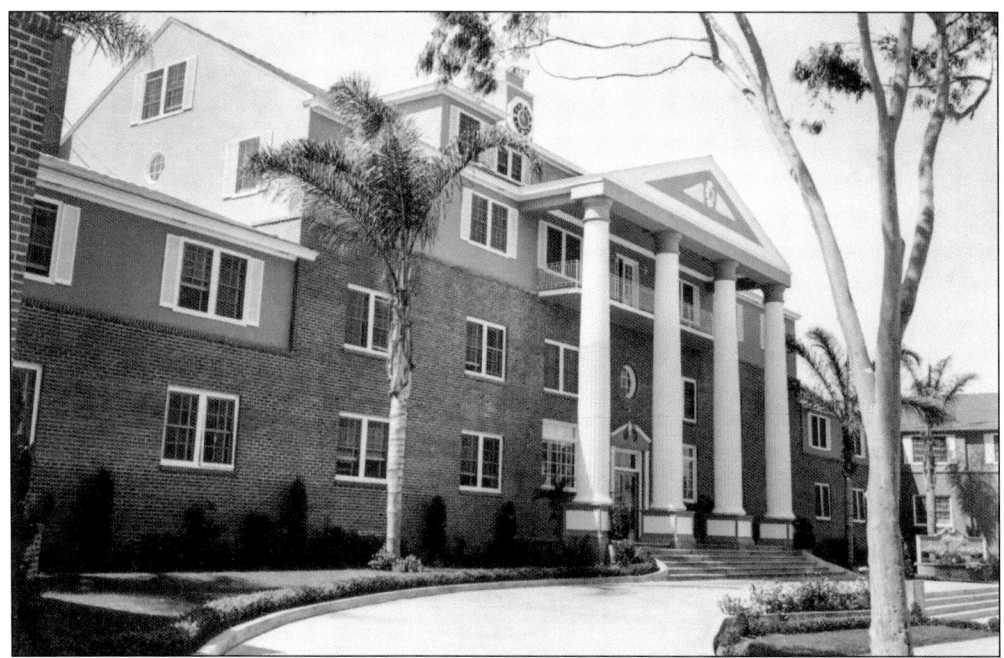

IMIG MANOR, 1946. The Imig Manor was completed in 1946. The original architectural drawings only had two floors. In an effort to compete with larger hotels downtown, builder Lawrence Henry "Larry" Imig added two floors and a penthouse for himself. The front, which faces El Cajon Boulevard, shows the grand Colonial style that Imig advertised as "Southern Style on the Miracle Mile." (Courtesy of Lafayette Hotel.)

IMIG MANOR UNDER CONSTRUCTION, 1943. Larry Imig, a young entrepreneur and home builder, began construction on the two-and-a-half-acre Imig Manor in 1943, his first large-scale commercial venture. This photograph shows the lot before construction, looking east from Mississippi Street. The hotel was the only hostelry project to be constructed in the country during World War II. (Courtesy of Lafayette Hotel.)

Larry Imig in His Element, 1940s. Whether he was looking to cause a scene or stay behind it, Larry Imig operated with a zest for life. He billed himself as "an Orson Welles of the construction world, cutting through red tape, shortages, and other problems that bog down the less aggressive." (Courtesy of Lafayette Hotel.)

Imig Manor Pool, 1940s. Johnny Weissmuller, who starred in the movie *Tarzan*, designed the grand hotel's Olympic pool. English Channel–swimmer Florence Chadwick practiced in the pool. Poolside loungers and divers could be viewed in the mirrored wall behind the diving board. (Courtesy of Lafayette Hotel.)

BOB HOPE AT THE IMIG MANOR, 1946. Larry Imig leveraged his well-honed skills as an entrepreneur, home builder, and flirt to kick-start the celebrity cult. The Imig Manor quickly became a legacy vacation resort and hideaway for stars like Bob Hope, Ava Gardner, Betty Grable, and Harry James. Bob Hope was the first person to sign the guest register in 1946. (Courtesy of Lafayette Hotel.)

HOTEL AERIAL VIEW, C. 1950S. The completed hotel had 243 rooms in the main building, 20 shops, four dining rooms, a 15,000-square-foot patio terrace for dining and dancing, and an Olympic-sized pool. There was also an apartment complex. Promotional material called it a "city within a city." With ownership changes in the 1950s, the Imig Manor eventually became the Lafayette Hotel, which it remains today. (Courtesy of Lafayette Hotel.)

A BEAUTIFUL GATHERING, C. 1950S. The Lafayette Hotel has hosted many meetings, parties, and celebrations. This fashionable gathering of lovely ladies is reputed to be a Daughters of the American Revolution meeting. Note the stunning circle skirts typical of the 1950s worn by the women in the front row. (Courtesy of Lafayette Hotel.)

ELDON'S SUNDRIES, C. 1940S. Larry Imig's sister Esther married Eldon Anderson, and they opened Eldon's Sundries in the northeast corner of the hotel. An advertising flyer for the store announced that it offered "a complete line of Toilet Goods, Medicine Cabinet Supplies, Vitamins and Baby Needs," and featured a fountain "for extra quality sodas, sundaes and malts." (Courtesy of Lafayette Hotel.)

SPECIALTY SHOPS, 1949. Along the north side of University Avenue between Thirtieth and Ohio Streets were the small storefronts of Parker's, William's Corsets, Judy's, Bob Coffman's, and Sandy's. Parker's and William's featured ladies' clothing and undergarments, Judy's sold juvenile furnishings, and Bob Coffman was a vendor of menswear and Sandy's a shoe store. Most recently, the building has hosted several restaurants, hair salons, a clothier, and a check-cashing business.

NATIONAL DOLLAR STORES, 1949. Once located on the northwest corner of University Avenue and Ohio Street, National Dollar Stores was one of North Park's several department stores, a branch of the company's original downtown store. Its curving second-floor corner display window was designed to visually appeal to shoppers approaching from both directions at this busy location.

WHITNEY'S BUILDING, 1949. Located on the northeast corner of University Avenue and Illinois Street, Whitney's was a popular neighborhood department store. Lady of the Lake, a book and gift store, has occupied the building in recent years. The brick "fin" sign is typical of many commercial buildings constructed or remodeled in the 1950s and remains, without a name, on the store building.

3100 BLOCK OF UNIVERSITY AVENUE, 1949. Developed during the post–World War II commercial building boom, this complex has contained a variety of stores, restaurants, and offices through the years. The only constant was Bob's Hollywood Bar, which lasted from 1949 until the 1980s, when it became an Irish bar. After remodeling, it reopened as the lively U-31 bar in October 2008.

MACFARLANE CANDY STORE, 1949. Proudly proclaiming their high quality, MacFarlane's boasted of their "Awful Fresh" candies. Sharing their building on the southwest corner of University Avenue at Thirty-first Street was French Bootery, a shoe store, and Singer, which sold sewing machines and vacuum cleaners. Later home to Drowsy Maggie's, a coffee house with live musical entertainment, the building has most recently housed Urbn Pizza.

PEP BOYS AUTO SUPPLY STORE, 1949. This popular store held its grand opening in 1949 at Thirty-second Street and University Avenue and operated there until 1970. It became a Goodyear Tire store in 1972 and a 99-Cent store in the mid-1990s. The store was closed after a fire gutted the building. A brand new Walgreens store was built on the site and opened in November 2006.

Woolworth Building, 1949. Woolworth's was one of the first major national retail chains in North Park. Built by Trepte Construction Company in 1949, the building on University Avenue is an excellent example of Modernist-style commercial architecture with Streamline Moderne influences. It is one of the most important mid-20th-century commercial buildings in North Park. "Woolworth" is imprinted on the terrazzo paving in front of the front doors. The building was designated historically significant in 2012.

MAYFAIR MARKET, 1949. Built on the former site of the Klicka Lumberyard, Mayfair was on the east side of Thirtieth Street between University and Lincoln Avenues. As one of North Park's first modern supermarkets, Mayfair was a shoppers' paradise to customers accustomed to the recent national food-rationing system of World War II. Later a Rite Aid drugstore, the building was displaced by the construction of La Boheme condominiums.

CLUB BELVEDERE/THE OFFICE, 1949. Located in an office and retail building at 3936 Thirtieth Street that was built before World War II, Club Belvedere opened as a cocktail lounge in 1949. It became The Office in 1959. The Scolari family bought it in August 1983 and renamed it Scolari's Office. In March 2008, the Scolaris sold the business, and after remodeling, it became just The Office again.

PALISADE GARDENS ROLLER SKATING RINK, 1987, AND SKATERS, 1966. Leonard, Robert, and Mortimer Zlotoff built this rink on University Avenue at Utah Street in 1945. John Wright, a World War II veteran of the 101st Airborne Division, operated the rink for 40 years. He helped revive the postwar Toyland Parade and introduced the sport of "rexing," a style of smooth backwards skating. As late as June 1985, a Senior Olympics skating competition was held there. But the popularity of skating declined, and attempts to activate the building as a performance theater failed. The building was torn down in the late 1980s for the Palisades Pointe apartments, a condominium/mixed-use project completed in 2006 and named Palisade Gardens is now on the corner. Below, in a rare interior photograph from October 1966, contestants for the Toyland Parade Queen title are roller-skating.

STREETCARS ON UNIVERSITY AVENUE, 1949. Streetcar 408 on the No. 7 line passes near Alabama Street. This car was painted an experimental bright orange for greater visibility after World War II, replacing the green and cream paint established in 1931 for the fleet. The color-change concept was discarded for other streetcars, but No. 408 remained orange until the end of its service. Below, Streetcar 405 is traveling westward and has just cleared the Georgia Street Bridge. The No. 7 line reversed on a Y track at University and Euclid Avenues to return to downtown. In 1948, the new owners of the electric railway system decided to modernize to diesel buses. The end of the line came on the morning of April 24, 1949, when the last streetcars rolled off the tracks. (Above, courtesy of Larry Hall; below, courtesy of San Diego Electric Railway Association.)

Four

THE PLACE TO BE

North Park was the place to live, play, and shop through the 1950s and early 1960s. Morley Field and other parks offered multiple and varied recreational opportunities. The North Park Theatre and commercial businesses along University Avenue, Thirtieth Street, and El Cajon Boulevard thrived. The J.C. Penney Company enlarged its department store at the corner of University Avenue and Ray Street, and businesses along the commercial streets successfully lobbied for removal of parking meters. The problematic Thirtieth Street Bridge over Switzer Canyon was finally replaced, but with an earthen embankment instead of the grand series of concrete arches envisioned by J.R. Comly in 1931. The emergence of car cruising by a newly affluent teenage population activated El Cajon Boulevard in some unexpected ways. Hundreds of thousands of spectators viewed Pres. John F. Kennedy's motorcade along El Cajon Boulevard in June 1963, creating a lasting memory.

NORTH PARK LIONS CLUB, 1950. Jack Hartley was elected as the first president when the club formed in 1926, and his brother Paul followed him in that position. A new hall, which serves the club today, was built at 3927 Utah Street in 1949. The group is celebrating Old Timers Day in front of their new building, which was constructed with funds collected from member donations. (Courtesy of North Park Lions Club.)

NORTH PARK LITTLE LEAGUE OPENING DAY, 1962. Thousands of boys, and later girls, have learned baseball through North Park Little League, established in 1957. One of the founders was Joe Schloss of A and B Sporting Goods in North Park, who coached a team for over 50 years. Photographed with the players are San Diego congressman Bob Wilson (right) and Mike Morrow, longtime supporter of youth baseball.

BALBOA PARK AND MORLEY FIELD, 1954. Upas Street stretches along the left side of the photograph in this eastward view from the Boy Scout Camp in Balboa Park toward Twenty-eighth Street. Roosevelt Junior High School and the War Memorial Building along Park Boulevard are in the middle ground. To the immediate right of the War Memorial Building is the original site of the Balboa Tennis Club, which dates from 1922. In the 1960s, the Balboa Tennis Club was relocated to Morley Field to make way for an expansion of the San Diego Zoo parking lot. To accommodate more tennis players, the number of tennis courts at Morley Field was increased from 10 to 25 and a new tennis clubhouse designed by Sim Bruce Richards was built. The 10 original tennis courts, the Bud Kearns Pool, and the old velodrome are in the upper center of the photograph.

WATER TOWER AND RESERVOIR, 1951. Water treatment and storage facilities once covered two full blocks south of El Cajon Boulevard between Idaho Street (right) and Oregon Street (left). The treatment and aeration facilities were located within Howard Avenue, which was not open to automobiles or pedestrians. The large rectangular reservoir was demolished in 1967 and is now North Park Community Park.

MORLEY FIELD AERIAL VIEW, 1964. This aerial photograph shows the Morley Field Sports Complex with the tennis courts prior to expansion, baseball and softball fields with grass, and the oval dirt-track velodrome, which appears to be overgrown. The left side shows the grading and roads related to the landfill operations in Arizona Street Canyon. The landfill operated until 1974.

BALBOA PARK MUNICIPAL POOL, 1951. Thanks to a bond issued for unemployment relief, the municipal pool opened in 1933 to a dedication ceremony arranged by the North Park Business Association. At the time, it was one of the largest swimming pools in California, measuring 131 feet long and 85 feet wide. The outdoor pool ranges from two-and-a-half to nine feet deep and is tiled in white. The accompanying Spanish-style building provides dressing rooms, storage, and offices. The building is roofed with red tile and decorated with colorful tiles on the walls and floors. The pool was later named for Bud Kearns, the director of recreation for the City of San Diego from 1928 to 1948. It is part of the Morley Field Sports Complex, which in 1934 was named for John Morley, superintendent of parks from 1911 to 1938.

EAST ON UNIVERSITY AVENUE FROM THIRTIETH STREET, 1955. The North Park sign was first suspended above this busy intersection at the very heart of the business district in 1935. The two-story structure with the "Dollar Days" banner (center) is the J.C. Penney department store. Recently, Wang's of North Park, a popular and elegant Asian restaurant, has occupied the building.

STEVENS AND HARTLEY BUILDING AND ANNEX, 1953. North Park's original three-story commercial building, constructed in 1913, received a Mediterranean-style annex (extending to the left) with arcaded facade and tower units in 1926. In the east tower, Dan Harmer and Robert Dent operated a shoe store that grew into a small department store by 1930. The tower caps still extend above the smooth stucco slipcover facade seen today. (Courtesy of the Hartley family.)

REMOVAL OF PARKING METERS, 1959. Businesses in North Park successfully lobbied the city to remove all parking meters in the commercial area of North Park along University Avenue and Thirtieth Street. Lillian Warboys, a sales associate at the J.C. Penney store, is looking at the shroud that city workers covered the meters with prior to their removal.

FLOWER BOXES ON PARKING METER POLES, 1961. When the city removed the parking meters in 1959, they left the poles in the hope of someday replacing the meters. North Park merchants added flower boxes to improve the aesthetics. Joan Prewitt, who was employed at Phillip's Men's Wear, is watering the flowers. The meters never returned, and the poles were eventually removed.

53

THIRTIETH STREET BRIDGE DEMOLISHED, 1956. After 48 years of being resurfaced, patched, and repaired scores of times due to heavy traffic, floods, and several Switzer Canyon fires, the Thirtieth Street Bridge was closed to traffic on August 27, 1956, for replacement by an earthen causeway. The causeway was part of a $400,000 project, which included Nile Street improvements in the eastern section of North Park. Designed by A.K. Fogg, the city engineer, the causeway was constructed of landfill from the Nile Street project. Shortly after the street closure and during the bridge demolition, a bulldozer working on the project cut into an 18-inch water main, flooding the municipal golf course and disrupting water service to a five-block area. During the eight months of the bridge closure, traffic was detoured along Thirty-second, Juniper, and Redwood Streets. (Both, courtesy of Vicki Granowitz.)

THIRTIETH STREET OPENING, 1957. Eight months after the Thirtieth Street Bridge was demolished, the newly completed causeway spanning Switzer Canyon from Palm to Maple Streets opened with a grand ribbon cutting on May 23, 1957. Constructed of 60 feet of fill at its midsection, the causeway ran for a quarter-mile and included wider vehicular pavement, sidewalks, and concrete retaining walls. The North Park Businessmen's Club sponsored the opening ceremonies. Mayor Charles Dail (below, center) cut the ribbon and declared the road open. Councilmen Kerrigan, Evenson, Tharp, Schneider, and Curran attended, and Miss San Diego Kathy deKirby lent the mayor a hand. Ed Vitalich from the North Park Businessmen's Club, city engineer A.K. Fogg (who designed the project), and city traffic engineer Jim Reading also attended.

NORTH PARK THEATRE, 1950S. The North Park Theatre remained a key entertainment venue through the 1960s with first-run Academy Award–winning movies, such as *Giant* starring James Dean, Elizabeth Taylor, and Rock Hudson. Teen idol James Dean died in an auto accident late in the making of *Giant*. The theater also had Saturday matinees popular with younger people. (Courtesy of B'hend and Kaufmann Archives.)

OSCAR'S DRIVE-IN ON EL CAJON BOULEVARD, 1947. In 1941, Robert Peterson opened the first Oscar's Drive-In restaurant. Other locations followed throughout San Diego and became very popular. In 1951, Peterson introduced the Jack in the Box drive-through restaurant, which became even more popular, growing into a national chain. Two early Jack in the Box restaurants were built in North Park; they remain at El Cajon Boulevard and Kansas Street and at Thirtieth and Upas Streets.

DRAGSTER PROTEST, 1960. Two young women in a Corvair are stopped by San Diego police along El Cajon Boulevard as part of protests against the closing of a drag strip at Miramar Naval Air Station. El Cajon Boulevard was the center of the postwar hot rod cruising culture because it was wide, straight, and long, and several drive-in restaurants were located on it.

DRAGSTER RIOT, 1960. The dragster protests culminated in a riot by more than 2,000 persons on August 21 and 22, 1960. The protests resulted in 116 arrests on August 21 and another 100 on August 22. This photograph shows those arrested being put into a San Diego Police Department paddy wagon.

HARTLEY ROW WEST, 1966. When the No. 2 streetcar line on Thirtieth Street joined the No. 7 line on University Avenue, the intersection became the "Busy Corner." The Hartley family built shops on their land along the southeast corner in 1912. Known as Hartley Row, the entire block of shops was remodeled in 1926 to look like a single structure and remodeled again in 1939.

HARTLEY ROW EAST, 1966. Along the south side of University Avenue from Thirtieth to Ray Streets were these specialty shops. Dee's sold ladies' hats, Tops And Bottoms featured sportswear separates, Burdine was a local family-owned jewelry store, and Brody's was a menswear and shoe store. A and B Sporting Goods, run by the Schloss family, still occupies the same store building and also sold phonograph records for many years.

LERNER SHOPS, 1966. Looking toward the southeast corner of University and Grim Avenues, several of the commercial district's long-gone businesses are pictured. In its prominent corner location, Lerner Shops was part of the popular chain of ladies' fashion stores, and Kay Jewelers and Woolworth (then doing business as Worth Mart) were also local branches of big chain stores.

J.C. PENNEY, 1966. This national department-store chain bought Paul Hartley's Automobile Garage at the corner of University Avenue and Ray Street in 1941. After a construction accident resulted in partial collapse of neighboring Fire Station 14 and its high tower, a new fire station was built at Thirty-second Street and Lincoln Avenue. The Penney's store, now Wang's of North Park, was enlarged to its current appearance in 1954.

59

PRESIDENTIAL PARADE ON EL CAJON BOULEVARD, JUNE 6, 1963. Pres. John F. Kennedy rode in a 10-mile-long parade route along El Cajon Boulevard on his way to giving the commencement address at San Diego State College, where 30,000 people jammed into Aztec Bowl to hear him. Over 250,000 people lined the parade route that started in North Park at Park Boulevard. Below, the president is standing behind an unidentified passenger who appears ready to spring into action. With President Kennedy in the back-seat area are, from left to right, California governor "Pat" Brown (wearing glasses), US senator Clair Engle, and local congressman Lionel Van Deerlin. Five months later, the president was assassinated in Dallas, Texas.

Five

CHURCHES AND SCHOOLS

As residential development began to flourish in the North Park area around 1910, the need for religious institutions and elementary schools close to home grew. Many religious institutions started in private homes. As congregations of various faiths expanded, they purchased parcels for eventual construction of a place to worship. They often held their first services in tents. When the financial resources were finally obtained, they built churches, synagogues, auditoriums, and social halls. Some congregations expanded their role in the community by establishing schools as well, such as St. Patrick's Catholic parish. The Augustinian Order established St. Augustine as a high school for boys in 1922. Other early churches include North Park Community, Immanuel Evangelical, Park Villas Congregational (later Plymouth Congregational), Trinity Methodist, North Park Baptist, Grace Lutheran, and St. Luke's Episcopal. Beth Jacob Orthodox Synagogue was built in 1950, and Tifereth Israel Synagogue was built in 1948. Although these two congregations left North Park in the 1970s, their buildings still serve religious purposes. Early public elementary schools include Jefferson, Garfield, and McKinley. Although technically not in North Park, Hoover High School and San Diego High School have educated many of the community's teenagers. Not all religious institutions and schools that have helped shape North Park could be included in this chapter, but their worthy stories are all reflected in those highlighted.

ORIGINAL TRINITY CHURCH, 1915, AND NEW CHURCH, 1960s. A visitor to the 1915 Panama-California Exposition, Rev. Walter Grant wanted to stay in San Diego and decided that the residential area around Upas and Thirtieth Streets could use a Methodist Episcopal congregation. The first chapel (above) was placed on borrowed land near Upas and Thirtieth Streets. Later, the chapel moved to land purchased at Grim Avenue and Thorn Street. In 1922, the congregation had outgrown the original chapel and two side wings and decided to build a larger church. The new church at 3030 Thorn Street (left) was dedicated on November 2, 1924. (Both, courtesy of Trinity Methodist Church.)

TRINITY CHURCH CHOIR, 1930s, AND CHURCH INTERIOR, C. 1960s. The above photograph of the Trinity Methodist Church choir at 3030 Thorn Street is from about 1932. The choir members are identified by last name as, from left to right, (first row) Calkins, Oberg, Crow, Fitzpatrick, and Doty; (second row) Ditmar, Howard, Miller, Reverend Mahood, Jacobson, Ellers, Black, and Franklin. Right, the interior of Trinity Methodist Church is pictured with a later choir. (Both, courtesy of Trinity Methodist Church.)

SYNAGOGUE GROUNDBREAKING, 1950. The Beth Jacob Orthodox Synagogue broke ground on March 26, 1950. Located on Thirtieth Street between Meade and Monroe Avenues, it was one of two Jewish congregations in North Park during the mid-20th century. The building is now home to St. John Garabed Armenian Church. Many structures in the photograph are still standing, including several houses on Thirtieth Street and the water tower. (Courtesy of the Covington family.)

ARCHITECTURAL DRAWING OF TIFERETH ISRAEL SYNAGOGUE, 1948. The Tifereth Israel Congregation was established in 1906. To serve a growing Jewish population, the congregation built a new synagogue at Howard Avenue and Thirtieth Street in 1948. In the late 1970s, the congregation moved to a larger facility in the San Carlos area and sold the building on Howard Avenue to Covenant Presbyterian Church.

PLYMOUTH CONGREGATIONAL CHURCH, 1958. Architect William Wheeler designed this Spanish Revival–style church in 1922. Damaged by a fire in 1965, it was rebuilt in 1977 in its current Modernist style. It has always played a major role in North Park. The first 3,000-book North Park Public Library was located in the church buildings in 1924; currently, both Head Start and Alcoholics Anonymous programs are held there. (Courtesy of Plymouth Congregational Church.)

ST. PATRICK'S CHURCH, 1929. Architect Frank Hope Jr. designed this Romanesque Revival–style church, which was completed in March 1929 in time for Easter services. The elaborate concrete building features a west-facing rose window with saints depicted in stained glass. The parish house next door (right) was restored in 2012 to its original Craftsman glory with volunteer assistance from parish members.

ST. PATRICK'S SCHOOL, 1944. This wooden building, which served as the original church and hall, was constructed in 1922 at Dwight and Ray Streets. In 1944, the building was renovated as a temporary two-room school by enlarging exit doors and adding windows and plumbing. In the fall of that year, two nuns taught 50 students divided into three grades. Because of limited space, lunch hour took place on the curb along Dwight Street, which was closed during school hours (below). Father John Burns, a professor from Villanova College who became St. Patrick's fifth pastor in 1943, was the driving force behind establishing a school for the parish. The building was sold and removed in 1949 when a new parish school was developed. (Both, courtesy of St. Patrick's Church.)

ST. PATRICK'S SCHOOL EXPANSION, 1948. In September 1947, the school was becoming extremely crowded, with five nuns and 181 students in seven grades. Father Burns wrote to Bishop Charles Buddy, "We have the opportunity to secure a fairly large Quonset Hut from the State Board of Education for $535.00." The first step was to remove the existing building (above). The hut was successfully added in February 1948 (below) and hosted graduation parties as well as classes. (Both, courtesy of St. Patrick's Church.)

ST. PATRICK'S SCHOOL COMPLEX, 1949. Expansion of the school, a convent for the teaching nuns, and additional playground space remained a vision for the parish. The new complex of school buildings, a parish hall, and convent opened in the fall of 1949, with seven nuns teaching 254 students in eight grades. This view is along Ray Street to the right at Capps Street. (Courtesy of St. Patrick's Church.)

ST. PATRICK'S STUDENTS, 1952. Dapper school-safety patrol boys stop traffic along Thirtieth Street at Dwight Street so students can cross the busy street. (Courtesy of St. Patrick's Church.)

LETTER TO MRS. KENNEDY, 1963. Sister Mary Cletus of St. Patrick's Convent in North Park wrote this heartfelt letter of condolence to Jacqueline Kennedy on November 24, 1963. Sister Cletus referenced the thrilling experience of seeing President Kennedy in his motorcade that had traveled along San Diego's El Cajon Boulevard in June. The reply from Mrs. John F. Kennedy stated, "Mrs. Kennedy is deeply appreciative of your sympathy and grateful for your thoughtfulness." (Both, courtesy of St. Patrick's Church.)

COPY

St. Patrick's Convent
3014 Capps Street
San Diego 4, California
November 24, 1963

Dear Mrs. Kennedy,

You may never see this, but if you do you might like to know that Jerry Lopez, an eighth grade boy, made this Spiritual Bouquet card for the repose of the soul of the President.

Last June here in San Diego, I had the privilege of seeing the President go by in his motorcade. At the time we all commented on his strength, vigor, and real manliness. We were especially thrilled because he appeared to recognize us, a group of Sisters standing on the sidewalk. This is a wonderful incident that I shall never forget. I'm sure there are thousands of other Americans who will cherish this same experience.

If we who never knew Mr. Kennedy personally, but only admired him for what he was can feel such an emptiness and sorrow, how much more must be your sadness at this time. Be assured of our prayers for your husband and also for you and your children. May God bless you and give you the strength and grace to bear this great loss.

Sincerely,

Sister Mary Cletus

Mrs. Kennedy is deeply appreciative of your sympathy and grateful for your thoughtfulness

Mrs. JOHN F. KENNEDY

Jacqueline Kennedy

Sister Mary Cletus
Saint Patrick's School
3014 Capps Street
San Diego 4, California

1963 1963

JEFFERSON ELEMENTARY SCHOOL, 1924. The architecture of the Jefferson school has gone through many changes since opening in the heart of North Park on Utah Street in 1913. The first phase of the school was a single-story, four-room building with French doors. For a century, Jefferson Elementary has strived for academic excellence—a tradition inspired by Pres. Thomas Jefferson, who founded the University of Virginia after his presidency.

JEFFERSON KINDERGARTEN, 1916. Mable and Myra Horton, twin sisters who lived in a house across from the school on Utah Street, are fifth and sixth from the left in the front row of Jefferson Elementary School's 1916 kindergarten class. The girls continued at Jefferson through the sixth grade, attended the first class at Roosevelt Junior High School, and graduated from San Diego High School in 1928. (Courtesy of Donna Couchman.)

JEFFERSON SIXTH GRADE GRADUATION, 1955. Myra Horton's daughter Donna Couchman followed in her mother's footsteps. In this sixth-grade graduation photograph of well-dressed students posing on the front lawn of Jefferson Elementary School, Couchman is the third girl from the left in the second row. She graduated from San Diego High School in 1960. (Courtesy of Donna Couchman.)

JEFFERSON ELEMENTARY MAYPOLE, 1955. In a charming ceremony reflective of the times, graduating sixth graders at Jefferson Elementary School dance around a maypole while proud parents watch. The courtyard of the school behind the original central building and one of the side wings can be seen in this photograph. (Courtesy of Donna Couchman.)

71

GARFIELD SCHOOL, C. 1923. This school has evolved since opening in 1913 south of El Cajon Boulevard and later moving north. Originally an elementary school, the curriculum was refocused in the 1970s to become Garfield Continuation High. In 1999, Garfield High relocated toward downtown and Garfield Elementary reopened for North Park youth. To honor the school's history, the name Garfield was kept, despite there being two Garfield schools in San Diego.

MCKINLEY ELEMENTARY SCHOOL, 1928. Built in 1924, McKinley Elementary School's inaugural class was welcomed into all 13 classrooms on February 2, 1925. Almost immediately, the school began adding facilities to meet increasing community needs. This original two-story building designed by Richard Requa and Herbert Jackson was replaced in 1973 due to earthquake safety concerns. Generations of families have attended the school and remain active in the McKinley Alumni.

WE DO GOOD WORK, 1954. Young McKinley students are encouraged to do their best as they carefully select the most appropriate crayon for the task. When they graduate, perhaps they will sing the class song written by 1951 sixth-graders Lois Fishburn and Nancy Zitlau, which begins: "Goodbye McKinley School, we've all enjoyed the years we've been here. Goodbye to friends we've met and to our teachers dear." (Courtesy of McKinley School.)

LEARNING ABOUT THE AIRPORT, 1953. McKinley students in Miss Hahn's Room 6 learn about Lindbergh Field through models, photographs, displays, and audiotapes on headphones. After the school's construction in 1924, multiple classrooms, the outdoor Greek Bowl, a cafeteria—and later a newer cafeteria, kitchen, and auditorium complex—were added. (Courtesy of McKinley School.)

MCKINLEY HALLOWEEN CARNIVAL, 1955. The Halloween Carnival organized by the PTA featured a haunted house, cakewalk, games, and booths selling items handmade by parents. The children's saddle shoes, Mary Jane shoes, princess costumes, hair made curly with bobby pins, cowboy shirt, and World War II helmet give the era away. The costumes may have changed now, but the joy this holiday brings to schoolchildren has not. (Courtesy of McKinley School.)

MCKINLEY CROSSING GUARDS, 1956. These neatly dressed boys in their distinctive sweaters and caps take their safety-patrol duties seriously. Bobby Fishburn, Lois Fishburn's brother, is in front holding the stop sign. Helping assure that students crossed streets safely was an honor in schools throughout San Diego County. (Courtesy of McKinley School.)

ST. AUGUSTINE HIGH SCHOOL, 1928. This private Catholic school for boys began on September 18, 1922, with 19 students meeting temporarily in Mission Hills. In 1923, the permanent school designed by Richard Requa (lower right) was built on Nutmeg Street, where it remains today. (Courtesy of St. Augustine High School.)

ST. AUGUSTINE CORE BUILDINGS, 1927. The school buildings designed by Richard Requa were described as "a monument of architecture embodying the most perfect type of Spanish Old Mission style" at the school's opening. The *San Diego Union* reported that "Covered archways, quaint porticoes, hidden recesses and enclosed courts remind the visitor of ancient Spain or quaint Mexico."

CLOCK CHECK IN THE CENTRAL COURTYARD, c. 1950s. St. Augustine High School is owned and operated by the Order of St. Augustine. Fr. David H. Ryan, a member of the order, is checking the clock in the central courtyard against his wristwatch. Members of the order pray each day at 5:00 p.m. (Courtesy of St. Augustine High School.)

ST. AUGUSTINE RADIO CLUB, 1950s. Fr. David H. Ryan (center) was a 1927 graduate of St. Augustine High School and taught at the school from 1940 to 1958 and 1970 to 1975. He is demonstrating radio equipment to students. (Courtesy of St. Augustine High School.)

St. Augustine Basketball, 1925 and 2013. Sports have been an integral part of the experience at St. Augustine since it opened in 1922. The high school has won many San Diego County California Interscholastic Federation championships in multiple sports, and many graduates have gone on to perform at both the collegiate and professional level. Above are the members of the 1925 basketball team. It took 90 years, but St. Augustine celebrated its first state championship by winning the Division III state title with a 59-52 overtime victory over San Francisco Sacred Heart Cathedral High on March 23, 2013. St. Augustine had come close in 2005 but lost in the title game. Coach Mike Haupt and the 2013 team are pictured below. (Both, courtesy of St. Augustine High School.)

HERBERT HOOVER SENIOR HIGH SCHOOL, 1933. Principal Floyd Johnson opened Hoover's doors to its first student body in 1930. He urged students to "let us dream for our school as we dream for ourselves." About the school, Pres. Herbert Hoover wrote, "I shall hope that it may long and usefully serve the young men and women who enter in search of truth and of leadership in moral and spiritual ideals."

LAYING THE CORNERSTONE FOR HOOVER HIGH SCHOOL, 1929. A large crowd assembles for the laying of the cornerstone of Hoover High School. The Masons donated a time capsule, and there was a Masonic ceremony for laying the cornerstone. After Hoover opened, North Park students were split between San Diego High School and Hoover High School.

HOOVER HIGH SCHOOL AERIAL VIEW, 1952. This aerial photograph shows the Hoover High School campus along El Cajon Boulevard. Between the two main classroom buildings was a small nicely landscaped courtyard often used as a location for yearbook and school-newspaper photographs. During the 1950s, one of the biggest sporting events each year in San Diego was the football game between Hoover High School and San Diego High School.

HOOVER HIGH SCHOOL TOWER DEMOLITION, JUNE 18, 1976. A two-ton wrecking ball swung into the five-story Hoover High School tower over a dozen times to make way for earthquake-resistant school construction. All 165 members of the first graduating class began the tradition of the Tower Book 46 years earlier, when they each signed the same leather bound book on the fifth floor to present to the school.

SAN DIEGO HIGH SCHOOL, 1951. One of the oldest public schools in California and the oldest in San Diego, the high school's roots trace back to Russ School, an elementary school established in 1882. By the mid-1880s, population growth created a need for a high school. Both elementary and high school classes operated at the Russ School until 1893, when the curriculum was adjusted for high school education only.

ROOM 20 STUDY HALL AT SAN DIEGO HIGH SCHOOL, 1912. By 1902, Russ High School was overcrowded, and a new larger school was planned and renamed San Diego High School. Designed by F.S. Allen, it opened in April 1907 and was quickly nicknamed the "Grey Castle." In the 1970s, the original school was demolished and replaced. The Grey Castle was the last part torn down in 1975.

AUTO CLASS AT SAN DIEGO HIGH SCHOOL, 1920s. Dating back to its days as Russ School, San Diego High School is the oldest school still on its original site. In this photograph, students are shown working on a car chassis and engine in automobile shop behind the main building of the Grey Castle.

SAN DIEGO HIGH SCHOOL GIRLS TENNIS TEAM, 1918. Although it would be more than 50 years before federal law mandated equality for girl's sports with boy's sports in high school athletics, young ladies always actively participated in sports. The scarves these girls are wearing were not part of a tennis uniform but were typical female fashion for San Diego High School through the 1920s.

AERIAL VIEW OF SAN DIEGO HIGH SCHOOL, 1926. This aerial photograph shows San Diego High School with the original single-deck Balboa Stadium and Russ Auditorium, which served as the civic auditorium. The school was located on land originally set aside for Balboa Park. Interstate 5 now extends across the top of the photograph. Balboa Stadium hosted many non-sporting events, including appearances by Charles Lindbergh, Pres. Franklin Roosevelt, and the Beatles.

BALBOA STADIUM CHARGERS GAME, 1964. Balboa Stadium was expanded in 1961 by adding a second deck after the Chargers decided to move from Los Angeles to San Diego. The Chargers were San Diego's first major-league sports team and had their ticket offices at the Lafayette Hotel on El Cajon Boulevard until San Diego Stadium opened in 1967. Balboa Stadium was demolished in the 1970s for seismic reasons.

Six

THE TOYLAND PARADE

Christmas festivals in North Park date to 1930, when the North Park Business Men's Association sponsored the dedication of a Christmas tree at the corner of Kansas Street and University Avenue. On December 11, 1934, a parade of decorated automobiles, theme floats, and four bands sponsored by the merchants was viewed by several thousand people at Thirtieth Street and University Avenue. This event established North Park's Christmas parade tradition. The December 10, 1935, *San Diego Union* reported that nine divisions with representatives of every major business in the community marched in the 1935 parade. Musical groups included the Bonham Brothers Band, and an estimated 30,000 spectators crowded the sidewalks. In 1936, Mayor Percival Benbough led the two-mile-long parade on horseback. In 1939, the parade was held on a Friday night; it lasted for over an hour as entrants marched between Thirty-second and Texas Streets. The 1941 parade, scheduled for the evening of December 12, was cancelled following the attack on Pearl Harbor and was not held for five years during World War II. Following the war, the parade grew. Inflated balloon figures were part of the 1949 parade. Live reindeer pulled Santa's sleigh in 1954, when 300,000 people watched from the sidewalks. There were 40 floats and 2,500 marchers in the 1955 parade. The 1956 parade started the selection of a parade queen. The 1957 parade included 35 floats, 65 horsemen, 25 bands, and 20 miscellaneous units. Jay North, who played Dennis the Menace on a top-20 television show, appeared in the 1960 parade and was typical of the celebrities who often participated in the parade. Before the 1958 parade, the North Park sign was enhanced to read "Home of the Famous Toyland Parade" on a banner below the neon "North Park." The parade's last year was 1966, and the North Park sign was removed in 1967. In announcing the cancellation, the *San Diego Union* identified the parade as San Diego's largest Christmas parade. The sign would not return until 1993, but the Toyland Parade was revived in 1985 and continues to be a North Park tradition.

SAN DIEGO ZOO PARTICIPATION, 1950S. The San Diego Zoo was a regular participant in the Toyland Parade. The photograph above shows their float in the 1956 parade passing in front of the North Park Theatre. The photograph below shows their entry, featuring camels and handlers in costumes, from the 1958 parade at Kansas Street and University Avenue. When the Toyland Parade was revived in 1985, the zoo participated by bringing an elephant along with the zoo's goodwill ambassador, Joan Embery, who was supposed to ride it in the parade. After the elephant was unloaded, it suddenly took off and decided to explore North Park, causing some real consternation among the handlers and Embery. That was the last time the zoo entered animals in the parade. (Above, courtesy of San Diego History Center; below, courtesy of Joe Schloss.)

APPALOOSA RIDER, 1940s. A beautiful Appaloosa horse with its distinctive spotted coat leaps off the ground, thrilling parade viewers at the Sabol Service Station on University Avenue east of Thirty-second Street. The station was known for its jaunty, roof-mounted "Tin Man" holding a wrench, which eventually found its way to the San Diego History Center. North Park Baptist Church is behind the service station in the background. (Courtesy of Chris Wray.)

THE LITTLE BAND LEADER, 1940s. This determined, dual-baton twirling Shirley Temple look-alike charms the multitudes at the Toyland Parade with her tall hat and furry boots. The crowd is six rows deep on University Avenue east of Thirty-second Street. (Courtesy of Chris Wray.)

BONHAM BROTHERS BAND, 1940S. Three Aida horns carry the leading banners for the Bonham Brothers Band. This youth marching band was started in 1921 by the brothers who ran the Bonham Brothers Mortuary. The band entertained at concerts, parades, and community events for 36 years before playing its last music in 1962. (Courtesy of Chris Wray.)

ACCORDIONS AND MORE ACCORDIONS, 1950S. During the 1950s, many children had the opportunity (or some say were forced) to learn how to play the accordion. Photographs and old movies of the Toyland Parade during the 1950s reveal seemingly dozens of floats with such fortunate children. This scene is in front of MacLean's Appliance store, most recently the Claire de Lune coffee shop at University Avenue and Kansas Street. (Courtesy of Joe Schloss.)

MARCHING BAND, 1958. This unidentified marching band was typical of the many bands participating in the parade. The San Diego State Marching Aztec band and bands from high schools and junior high schools throughout San Diego County were regular participants. In addition, Navy and Marine Corps units, civic groups, and music stores had marching bands. (Courtesy of Joe Schloss.)

PARADE AT LIFE MARKET, 1955. This float from the Muscular Dystrophy Association is passing the Life Market at Utah Street and University Avenue. Life Market became Glenn's Market, with its distinctive neon sign, and remained at the corner until 2012. That year, the owner relocated to a different building on University Avenue and took the Glenn's Market sign with him.

MARINE CORPS TOYS FOR TOTS TANK, 1958. The Marine Corps was a regular participant in the parade, usually in conjunction with their Christmastime Toys for Tots campaign. The 1958 parade featured a tank to convey the message. It is not clear what effect the tank treads had on University Avenue, or why the rider was dressed like a spaceman. (Courtesy of Joe Schloss.)

WELLS FARGO STAGE COACH, 1958. This scaled-down version of the Wells Fargo stagecoach driven by children was a charming entry in the 1958 parade. Equestrian entries were a big part of the parade in the 1950s, with participants coming in from throughout California and Arizona to show off their beautiful horses and fancy saddles and harnesses. (Courtesy of Joe Schloss.)

TOYLAND PARADE LIONS CLUB ENTRY, 1946. Toy blocks and presents march in front of the Nordberg Building (then the North Park Building), which housed a Thrifty Drug Store. At this time, the Toyland Parade marched at night. (Courtesy of the Hartley family.)

CHRISTMAS LIGHTS OVER THE PARADE, 1951. Merchant-sponsored Christmas lights in North Park date to the early 1930s. The North Park Business Club was established in 1924, and their Women's Auxiliary began raising money for Christmas lights and a community sign by 1925. In 1940, the Club purchased 20,000 feet of new Christmas lights for University Avenue, and the Toyland Parade traveled under lights through the 1950s.

89

AT THIRTIETH STREET AND UNIVERSITY AVENUE, 1958. North Park Toyland queen Diane Marjorie Storton and her court grace the float pulled by the North Park Lions Club automobile. The view is of the north side of University Avenue to the east from Thirtieth Street. Visible in the scene are Jessop's Jewelry store, See's Candies, and Arnell's, a women's clothing store in the building that was originally the Ramona Theater.

PALISADE GARDENS SKATING RINK, C. 1960. Although torn down in the late 1980s, Palisade Gardens roller-skating rink holds a special place in many hearts. Located at Utah Street and University Avenue, it offered a great vantage point for the parade. The Fiesta de las Flores is a City of La Mesa float celebrating their own civic event, which was started in 1928 by the La Mesa Chamber of Commerce.

90

RAQUEL WELCH, 1958. High school beauty queen Raquel Tejada was chosen Miss La Jolla and then Fairest of the Fair, which was the premier beauty contest in the county. As Raquel Welch, she became a star in movies such as *Fantastic Voyage* and *One Million Years, B.C.* The publicity poster for the latter film, featuring Welch in a deerskin bikini, became much more famous than the 1966 movie.

MARGARET FIELD, 1958. Also known as Maggie Mahoney, this television star of the 1950s and 1960s appeared in numerous shows including *Perry Mason*, *Wagon Train*, *The Virginian*, and *Twilight Zone*. One of her children is movie and television star Sally Field, who has twice won Academy Awards for Best Actress. Margaret Field passed away in 2011 at the age of 89. (Courtesy of Joe Schloss.)

MOTHER GOOSE IN THE TOYLAND PARADE, 1950s. Parade floats appeared interchangeably in various events. The popular Mother Goose Parade in El Cajon began in 1947 as a gift to children from the business community. It is traditionally held on the Sunday prior to Thanksgiving, preceding the Toyland Parade by several weeks. In this photograph, the Mother Goose float waddles down University Avenue west of Utah Street.

TOYLAND QUEEN AND COURT IN THE MOTHER GOOSE PARADE, 1966. Provided by the North Park branch of Bank of America on Thirtieth Street, this float featured employees of the bank. Waving graciously on the far right and wearing her flowing white prom dress is Maria Chimely DiGregorio, a 1964 Hoover High School graduate. (Courtesy of Maria DiGregorio.)

Seven

CHANGES AND REVITALIZATION

In the 1960s, development of the Interstate Highway System and regional shopping centers, such as Mission Valley Center, initiated a decline in the North Park shopping district. Outlying suburbs provided families with larger spaces, while smaller bungalows lost favor in the housing market. The combination of these real estate conditions with increasing population led to the demolition of many single-family homes in North Park and their replacement with apartment buildings. Properties with deep lots and convenient alleys were especially desirable to developers. The North Park sign came down and the Toyland Parade stopped after the 1966 event. In 1978, the crash of Pacific Southwest Airlines Flight 182 stunned North Park and the nation. However, things did move onward. Parkland replaced a concrete reservoir, and Morley Field received additional tennis courts, a new velodrome, and a disc golf course. Ball fields were rebuilt and the landfill closed. The North Park sign was replaced, and a new sign on El Cajon Boulevard signaled a rebirth of that area, also. People discovered the joy of owning a unique home in neighborhoods that were more walkable and bike friendly than the suburbs. Plus, with the area's central location, residents could avoid long commutes on freeways that were increasingly crowded. Beginning with pizza at Paesano in the 1960s and continuing today, new restaurants started by creative and innovative chefs have sprung up along with bars where craft beer is a given. Restoration of the North Park Theatre was a critical initiating event of the recent renaissance. North Park has been receiving national attention for being hip and historic, a status solidified by the listing of landmarks—such as the Georgia Street Bridge, Lafayette Hotel, and elevated water tank—in the National Register of Historic Places.

PAESANO RESTAURANT, 1966. Vincenzo Romano opened Paesano, the first Italian restaurant in North Park, at 3830 Ray Street, a building that had once served as the North Park post office. *Paesano* means "good friend" and is what one calls a compatriot upon forgetting his real name. The restaurant remained on Ray Street for five years before relocating to a new building at Thirtieth and Landis Streets. (Courtesy of the Romano family.)

PAESANO DELIVERY CAR, 1970. Vincenzo Romano washes his car with help from his daughter Silvia. He was often spotted about town in the Paesano delivery car. When Paesano opened in 1966, pizza was offered at only five restaurants in the San Diego area, and pizza delivery was a novelty. (Courtesy of the Romano family.)

POST OFFICE ON RAY STREET, 1937. Before this stucco and tile building was constructed in 1927 at 3830 Ray Street, people bought stamps at local drugstores. A new post office with American Colonial details was built in 1951 at the corner of Grim Avenue and North Park Way. That building was closed by the federal government in 2011 and has been repurposed as a mixed-use residential development. (Courtesy of the Covington family.)

RAY STREET NORTH FROM NORTH PARK WAY, 1966. Abramson's carpets was located on the west side of Ray Street for more than 30 years, closing in the 1970s. The Mission Revival–style store was built in 1927 for George Wittman, president of the Ideal Grocers Association. He operated his grocery store here through World War II. At mid-20th century, both the North Park post office and branch library were located in this block.

NORTH PARK LIBRARY, 1980s AND 2008. North Park's first public branch library opened with 3,000 books in a room at the Plymouth Congregational Church on University Avenue in 1924. Later, the branch operated on Ray Street until 1959, when it moved to a new Midcentury Modern–style building on Thirty-first Street at North Park Way (above). That branch library building was expanded in the early 1980s to provide more space, keeping much of its Midcentury design along University Avenue (below). Since the library had no parking, the city purchased the three houses immediately south of the new larger library, and those houses were demolished in 1988 for the new parking lot. (Above, courtesy of North Park Library; below, courtesy of Christian Michaels.)

FRANK THE TRAINMAN, 2013. Providing countless hours of imagination for youngsters and adults, Frank Cox opened his model-train business at 4310 Park Boulevard in 1943. In 1981, he sold his business to Jim Cooley. Although Cox died in 1989, the shop continues next to the J.A. Cooley Museum on Park Boulevard. The iconic neon sign was installed in 1947 and remains at its original location. (Courtesy of Valerie Hayken.)

MILLER'S GARAGE, 1930s. Miller's Garage, North Park's most elaborate full-service automotive center, stretched along the 3100 block of University Avenue between Herman Avenue and Thirty-second Street (lower center). Bill and Charley Miller built the large operation in 1928 and later expanded. The entire block became a Sav-On Drug Store and parking lot in the 1950s and has more recently been a CVS.

BANK OF AMERICA, 1967. In 1950, the bank opened to the public at 3933 Thirtieth Street, more recently the location of Cafe Calabria. A June 22, 1950, clipping from an unidentified newspaper described the new building as "one of the most imposing bank structures in Southern California." The bank had been in the corner of the North Park Theatre on University Avenue since 1928. (Courtesy of Bank of America Historical Collections.)

RETIREMENT TOGA PARTY, 1966. Clarke Osborne came to North Park's branch of the Bank of America as manager in 1934 and was the manager for the 1950 move to Thirtieth Street. At his retirement celebration, he is crowned with a laurel wreath for his lengthy service to the bank. The North Park branch moved to its most recent location at 3101 University Avenue on April 14, 1975. (Courtesy of Maria DiGregorio.)

DUDLEY WILLIAMS, 1967. The Optimist Club recognizes Dudley Williams (right), North Park resident and founder of Piggly Wiggly grocery stores in San Diego. Vince Sund, president of the Uptown San Diego chapter, presents the award. Clarence Saunders started the national chain of modern grocery stores, where customers helped themselves and paid cash, in 1916. Williams helped open the first store in Memphis, Tennessee, and moved to San Diego in 1922. (Courtesy of Vince Sund.)

PIGGLY WIGGLY ON JUNIPER STREET, C. 1955. This building now houses the Grove, a unique emporium at Thirtieth and Juniper Streets. The first Piggly Wiggly in North Park opened in 1922 at 3837 Thirtieth Street, more recently the location of George's Camera. A new Piggly Wiggly with a novelty—a parking lot—was built on North Park Way at Ray Street (now the Bargain Center) in 1939. (Courtesy of Vicki Granowitz.)

DEMOLITION OF OLD RESERVOIR, 1967. Sharing the same block as the University Heights Playground, the 18-million-gallon reservoir next to the elevated water tower was demolished in 1967. The space was converted to community parkland for the renamed and larger North Park Recreation Center. Looking on for the start of demolition are North Park dignitaries, including Miss North Park.

LAST POWER POLE REMOVAL, 1971. As a major traffic corridor, University Avenue had numerous utility wires strung between tall wooden poles, aesthetically marring the urban landscape. In this view, people gather just west of Ray Street to watch as this last pole comes down after the electric lines were moved underground.

Morley Field Aerial View, 1968. This aerial photograph shows the expansion of the number of tennis courts to 24, the new tennis clubhouse, and the tennis stadium under construction. In 1971, the tennis stadium was named in honor of San Diego tennis legend Maureen Connolly Brinker, who died of cancer in 1969 at age 34.

National Bicycle Champions, 1980. The first dirt-track velodrome at Morley Field was built in the 1930s and was used until the late 1940s. In 1976, a new paved velodrome was built. The San Diego Velodrome Association operates the facility, which is heavily used by local riders and has been the site of national competitions.

Air Disaster, 1978. At 9:00 a.m. on September 25, 1978, San Diego was in the midst of a Santa Ana. The temperature already was 80 degrees, and skies were clear for miles. Pacific Southwest Airlines (PSA) Flight 182 was flying at 2,400 feet above Thirty-eighth Street and El Cajon Boulevard in its approach to Lindbergh Field when it collided with a single-engine Cessna on a training flight out of Montgomery Field. The PSA plane crashed at Dwight and Nile Streets just west of Interstate 805, and the Cessna crashed around Thirty-second Street and Polk Avenue. It was the worst US air disaster up to that time, and 22 homes were either damaged or destroyed. A total of 144 people lost their lives: 7 people on the ground, 2 people on the Cessna, and all 135 people on Flight 182. An additional nine people on the ground were injured. (Courtesy of San Diego Union Tribune, LLC.)

EMERGENCY RESPONSE, 1978. Emergency responders examine debris from the PSA plane (above), and a resident uses a garden hose on the smoking rubble (below). Fire, police, and news organizations responded quickly. Smoke rising from the crash could be seen for miles. A temporary morgue was set up in the gymnasium at St. Augustine High School. In 1998, a memorial marker commemorating the event was dedicated at the North Park Library. A 2010 documentary film on the crash, *Return to Dwight and Nile*, recorded the lasting tragic impact on families who lost loved ones, and how, decades later, the horrific scene at the crash site still vividly haunts the memories of emergency responders. (Both, courtesy of U-T San Diego/ZumaPress.com.)

REMOVAL OF NORTH PARK SIGN, 1967. The one-ton neon North Park sign installed in 1935 over University Avenue and Thirtieth Street was removed in January 1967. It was to be replaced with a new revolving sign as a project of the North Park Business Club. The revolving sign was never implemented, and the original sign disappeared.

REVIVING THE PARADE AND SIGN, 1985. Patrick Edwards of the local business association that would become North Park Main Street led efforts to revive the Toyland Parade in 1985 and restore the North Park sign. This wooden sign is on top of a Volkswagen van driven by Gary Gardner, who made the sign. Edwards has been active in North Park Main Street and other community groups for more than 30 years. (Courtesy of Patrick Edwards.)

NORTH PARK SIGN, 2000. In 1993, twenty-six years after the original North Park sign was taken down, a new static sign was installed west of the original location. The replacement was the result of widespread community support. This photograph is looking east on University Avenue at Kansas Street by the Claire de Lune coffee shop.

THE BOULEVARD SIGN, 2001. In 1926, El Cajon Avenue joined US Route 80 to create the first automobile route connecting the Atlantic to the Pacific. In 1937, the city changed the name from Avenue to Boulevard, and the Boulevard became a popular evening spot, brightly lit with local businesses' neon signs. In 1989, this Boulevard sign was erected to pay homage to the street's colorful history.

VACANT NORTH PARK THEATRE, 2001. Last used as a church, the building closed to regular activities in 1985. In 2005, a grand dedication celebrated the successful restoration effort led by Bud Fischer in coordination with the City of San Diego and managing tenant Lyric Opera San Diego. The renovated theater's first performance, *The Mikado*, opened on October 14, 2005. David Cohen with the Verant Group leads current theater ownership and operation.

THEATER INTERIOR, POST-2005. The theater shines with original chandeliers restored by Gibson and Gibson. West Coast Tavern occupies the former theater lobby; a new theater entrance was created on Twenty-ninth Street. A million-dollar donation from the Stephen and Mary Birch Foundation helped fund the theater's restoration, which undeniably initiated a renaissance in North Park that continues today. (Courtesy of Paul Body Photography.)

Eight
COMMUNITY LIFE

Major buildings and significant events help create a community and relate its history. But the story is also told through people, whether they are children riding tricycles and ponies, families gathering around the dinner table and Christmas tree, or athletes playing on baseball fields and tennis courts. This chapter traces North Park's residents from the early 1900s to the present day in photographs that not only reflect unique personal moments, but also illustrate general community life at the time. Some people, such as baseball great Ted Williams and tennis star Maureen Connolly, are internationally known. Others are special within North Park. All have been, and some still are, vitally important to the story of the community.

GOODWIN FAMILY, 1902. Sarah and Jefferson Goodwin headed a large family from Texas and lived at 4329 Oregon Street, north of El Cajon Boulevard, in 1910. Pictured from left to right are (first row) Sarah, Jefferson, and daughter Henrietta; (second row) children Alice, Charles, Lela, and (possibly) Elizabeth. The family included other sons and daughters. Charles owned Goodwin Cleaners and Dryers, a downtown laundry, in the 1920s.

NORMAL SCHOOL, 1906. In 1907, Lela Goodwin attended the State Normal School, a teacher-training college that evolved to become San Diego State University. Located at Park and El Cajon Boulevards, the school was designed by Hebbard and Gill and looked like this postcard when Lela attended. In 1913, Henrietta Goodwin graduated from the Normal School, but was not allowed to become a full-time permanent employee of the public school system. (Courtesy of Katherine Hon.)

GONZALEZ BUSINESS, 1912, AND RESIDENCE, C. 1920. When a young man, Miguel Gonzalez worked at the Jorge Ibs Curios shop in Tijuana, Mexico, as a cleaning and handyman employee who later ascended to sales. In 1910, Miguel married Ella, daughter of Mr. Ibs, and by 1912, Miguel and Ella took over the store, renaming it Miguel Gonzalez Big Curios Store. Miguel became a highly successful businessman. In 1916, the Gonzalezes bought two lots along Twenty-eighth Street in the Blair's Highlands subdivision, where they built their home, shown in the painting below. The deeds for the area contained restrictive covenants that prohibited the property from being owned by anyone other than "a member of the Caucasian Race." The Gonzalezes' deed was modified to also allow ownership by someone of the "Mexican Race." The Gonzalez-Ibs family lived at the residence through 1960. (Above, courtesy of Ed Orozco; below, courtesy of Chuck LaBella and the Gonzalez family.)

BURLINGAME PROMOTION, 1912. In a masterpiece of innovative marketing, developers Joseph McFadden and George Buxton convinced a group of young ladies visiting from Arizona to pose under a billboard advertising the new Burlingame Tract. The mock wedding resulting from the billboard's promise featured June Salliday (first row, second from right) as the bride and Fred Peyton (top row, first on left) as the groom. Peyton became a resident of Burlingame.

STOCK FAMILY CANDY STORE, C. 1914. Just across University Avenue from the landmark Stevens and Hartley building, Frederick and Florence Stock's candy store was at the southwest corner of Thirtieth Street. The site has been most recently home to Union Bank, located in a building constructed in the late 1960s. (Courtesy of Michael Good.)

OUT FOR A SPIN, C. 1915. Enjoying his tricycle, this young man is photographed on a sunny day beside a wide unpaved street believed to be in the vicinity of Granada Avenue and Thorn Street. Developers often laid concrete curb, gutter, and sidewalk, but typically did not pave streets. (Courtesy of Michael Good.)

GOAT CART, 1927. Roland Blase and his brother Wendell pose at 3960 Oregon Street. Traveling photographers in the 1920s and 1930s often photographed youngsters in a wagon drawn by a goat. With its impressive horns and long locks, this is likely an Angora goat, a popular companion choice for the photographers. The cart conveniently provides the location and year of the photograph for posterity. (Courtesy of Roland Blase.)

WELL-DRESSED LAWN MOWING, 1928. As a proper gentleman, George Parkman wore a starched collared shirt and bow tie with his coveralls while mowing his yard at 3668 Twenty-eighth Street. He is shown here with his push lawn mower of that era. His Craftsman home remains in fine condition within the boundaries of the North Park Dryden Historic District. (Courtesy of Donald Madison.)

TEXAS STREET FAMILY, 1927. Arthur and Rolene Emmons are shown with their children Doris and William in front of their bungalow north of Dwight Street. As proprietors of the nearby Emmons hardware store on Upas Street, they presumably had a short drive to work in their Chevrolet sedan. (Courtesy of Charlene Craig.)

THE BARROWS FAMILY, 1929. The Barrows family, headed by John Sr. and wife Leslie, moved to Utah Street in 1927. This view is looking north on Utah Street before the Masonic Temple was built. Little Frances is in front. Other family members are, from left to right, Laurence, Leslie, John R., John Sr., and Eleanor. The house was built by Leslie's parents, Ella and Henry Foote, in 1909. (Courtesy of F. Ilig.)

THE HORTON FAMILY FLYERS, 1929. The Horton family members were aviation enthusiasts at a time when that activity was novel. The twins, Mable and Myra, and older brother Harry (center) are pictured wearing their aviation gear at their home on Utah Street. Younger brother David later became an accomplished airman in World War II. (Courtesy of Donna Couchman.)

MODEL AIRPLANES, 1935. On their parents' Twenty-ninth Street front porch, Donald Madison (right) and his sister Virginia proudly display some of the model planes he constructed near the beginning of his lifelong interest in all things related to aviation. (Courtesy of Donald Madison.)

FIRST CAR, 1941. At age 16, Donald Madison takes delivery of his handsome 1934 Ford, purchased for $210 from his prudently saved newspaper-route earnings. In the driveway to the right is his father's Willys sedan. (Courtesy of Donald Madison.)

NORTH PARK BOYS BAND, 1938. The ladies of San Diego High School's drill team, wearing their snappy white uniforms, join the North Park Boys Band at Lane Field for a musical event. Private bands were popular and competitive at this time. C.E. Romero directed the North Park Boys Band in the late 1930s; the band led several North Park Christmas parades and entertained at many events. (Courtesy of Bruce Guy.)

CHURCH SUMMER PROGRAM, 1937. With costumes evoking flowers of spring, one can only guess at the theme of this summer program for children attending Scott Memorial Baptist Church, located at 2716 Madison Avenue. While most of the girls appear delighted with their tiered dresses and imaginative hats, Raymond Cooper (back row, second from right) remains serious about his role, possibly because his father was a church deacon. (Courtesy of Raymond Cooper.)

NOBUKO SATO, C. 1950. When she was not working at the family fruit stand at 3794 Thirtieth Street, Nobuko Sato, (back row, center, without hat) was an active member of the Ocean View United Church of Christ, which had a predominantly Japanese congregation. The Sato family lived at 3304 Thirtieth Street and was sent away to the Poston, Arizona, incarceration camp in 1942. (Courtesy of Japanese American Historical Society of San Diego.)

GRADUATION CERTIFICATE, 1945. North Park's Japanese American residents were among the 120,000 people required to leave the west coast in 1942. Paul Kaneyuki completed the 10th grade in the incarceration camp at Poston, Arizona, returning to San Diego in 1945. The Kaneyuki family worked at Ishino Fruits at 3009 Thirtieth Street before starting their own business on Thirtieth and Beech Streets in 1930. (Courtesy of Japanese American Historical Society of San Diego.)

LESLIE FOOTE BARROWS, 1959. Leslie Barrows went to work at the San Diego Public Library during World War II and retired as head of the newspaper department in May 1952. In her retirement, she enjoyed weaving American Colonial patterns on her loom in the living room of the "Cottage," her Utah Street home that was originally built by her parents in 1909. (Courtesy of F. Ilig.)

FAMILY AND FRIENDS AT THE COTTAGE, 1942. Leslie Barrows sits at the head of the table at a family dinner. First on the left is her son John R., a talented musician who discovered, produced, and introduced a new French horn effect in 1934 that gave him worldwide notoriety. Youngest daughter Frances is third from the right. (Courtesy of F. Ilig.)

BACKYARD EXPRESS, 1949. With building help from their grandfather E.M. Wisemore, a former railroad fireman, Randy Sappenfield (left) and his brother Gary enjoy their pretend train made of wooden boxes, a barrel, and coffee cans at 3767 Thirty-first Street. Lacking any coal for the tender, their dog Topper kindly substituted. (Courtesy of Randy Sappenfield.)

TOPPER'S BIRTHDAY PARTY, 1949. Joining his owners Randy Sappenfield (right) and Gary Sappenfield in their backyard at 3767 Thirty-first Street, Topper the dog was treated to his own birthday cake and dog-biscuit gifts from his family. He is sporting a napkin at mom's insistence, to avoid needing a bath after the celebration. (Courtesy of Randy Sappenfield.)

A CLASSIC PONY PICTURE, C. 1947. Young Donald Taylor, a cowboy fanatic, sports his treasured Christmas presents of a flannel shirt, scarf, and holster with cap gun in front of his home at 3426 Texas Street. He is riding a pony provided by a traveling photographer who appeared one sunny day and offered to take his picture for 50¢. Happily, "Mother consented," Donald wrote on the back of the photograph. (Courtesy of Donald Taylor.)

A THIRTY-FIRST STREET GUEST, 1944. Visiting from Kansas, fashionable Mildred Gillette poses on her suitcase in front of her cousin's home at 3767 Thirty-first Street. Visible behind Mildred are the now long-gone homes on the west side of Thirty-first Street at Wightman Street, later renamed North Park Way. (Courtesy of Randy Sappenfield.)

MUSCLE BEACH SAN DIEGO STYLE, 1946. Leo Stern, a bodybuilding institution, formed The Hillcrest Barbell Club with friends in 1939. He won the Mr. San Diego bodybuilding competition in 1941 and the AAU Mr. California title in 1946. That year, he established Stern's Gym near Hoover High School; in 1947, he moved the gym into bigger premises on Granada Avenue near North Park Way, where it remains. (Courtesy of the Stern family.)

ODD LIFT, 1948. Stern's Gym attracted professional and amateur athletes, including Arnold Schwarzenegger, Lou Ferrigno, Bill Pearl, Earl Clark, and many Chargers football players. Pat Casey, the first man to officially bench 600 pounds in the 1960s, also trained under Leo Stern. Starting in 1947, Leo Stern (center) staged physical-culture variety shows with "odd lifts" to make weight lifting more interesting for families and friends of competitors. (Courtesy of the Stern family.)

BETTYE STERN, 1965. Leo Stern's wife, Bettye, shared her husband's passion for fitness. She was the trainer and owner of a very successful woman's health studio called Bettye Stern Ladies Gymnasium on Utah Street (the Stern family residence since 1946), just a block from Stern's Gym. She passed away in 2006. (Courtesy of the Stern family.)

LEO STERN AND FAMILY, 1958. Leo Stern stood as an icon in the fitness industry for over six decades. He passed away in 2009, but his gym still bears his name and continues his legacy of assisting individuals in achieving their fitness goals. Pictured in this holiday photograph are Leo and his wife Bettye, with, from left to right, sons Michael, David, Dennis, and William. (Courtesy of the Stern family.)

TED WILLIAMS AS A SAN DIEGO PADRE, 1936. Ted Williams signed with the minor-league Padres after finishing his senior season at Hoover High School when he was 17 years old. He also played for the minor-league Padres in 1937 before being traded to the Boston Red Sox. By 1939, he was in the major leagues. He played his entire major-league career with the Red Sox, won six batting titles, and twice was voted Most Valuable Player of the American League. Despite missing almost five seasons for military service in World War II and Korea, he had 2,654 hits, 521 home runs, and 1,839 RBIs, with a career batting average of .344. He retired after the 1960 season and entered the Hall of Fame in 1966. He was the last major to hit over .400 in a season: .406 in 1941.

TED WILLIAMS AT MOTHER'S HOUSE, 1946. Ted Williams smiles on the front porch of the house he grew up in at 4121 Utah Street. Discharged in January from the Marines, Williams was on his way to spring training. In 1946, he hit .342 with 38 home runs and 123 RBIs. He was voted Most Valuable Player in the American League and played in his only World Series that year.

TED WILLIAMS VISITS HOOVER HIGH SCHOOL, C. 1977. Ted Williams (right) regularly came back to San Diego to visit. This photograph shows Williams visiting his alma mater, Hoover High School, with a future Hall of Famer, pitcher Tom Seaver. The baseball field at the North Park Recreation Center where Williams first played baseball is now named Ted Williams Field in his honor.

Wilbur Folsom Appreciation Day, October 28, 1967. Despite losing his left leg in an accident at age 18, Wilbur Folsom taught tennis to hundreds of people in a 35-year career. First at the University Heights Playground and later at Morley Field, he became known as the "Architect of Champions." He died in 1968, and in 1971, the City of San Diego named the tennis complex at Morley Field after him. (Courtesy of Ben Press.)

Famous Students, 1956. Two of Wilbur Folsom's most famous students were Ben Press (left) and Maureen Connolly (right). Press grew up on Utah Street near Ted Williams and Connolly, with whom he often played tennis. He attended San Diego High School and was an All-American tennis player at UCLA. He has coached tennis for over 60 years, including 28 years as head pro at the Hotel del Coronado. (Courtesy of Ben Press.)

TENNIS CHAMPION MAUREEN CONNOLLY, 1951. Born in 1934, Maureen Connolly grew up in a house at 3984 Idaho Street, steps away from the tennis courts at the University Heights Playground, now the North Park Recreation Center, where she learned to play under the legendary Wilbur Folsom. In 1951, at age 16, she won her first US Open at Forest Hills, becoming the youngest women's champion at that time.

MAUREEN CONNOLLY AND TROPHIES, 1954. Connolly won nine Grand Slam Singles titles in her too-brief career: the US Open in 1951, 1952, and 1953; Wimbledon in 1952, 1953, and 1954; the French Open in 1953 and 1954; and the Australian Open in 1953. A horseback-riding accident that broke her leg ended her tennis career in 1954 at age 19. She died in 1969 at age 34 of cancer.

JOE AND DAVID SCHLOSS, 1970. David Schloss (right) took over A and B Appliance during World War II. He played Santa in the Toyland Parade for decades. His son Joe (left), who still mans the store on University Avenue with his son Gregg, has coached Little League since 1955 and has a baseball field named after him at Morley Field to honor his commitment to children. (Courtesy of Joe Schloss.)

VERNETTA AND DANCERS, 2005. Crowned Little Miss Hollywood in 1944 and first runner-up in the Ms. San Diego pageant in 2013, Vernetta Bergeon (center) has been a North Park dynamo since the 1960s. In the 1980s, she tried to save the Palisade Gardens skating rink as a performance theater. She has trained thousands in dance and is a past president and active member of the North Park Lions Club. (Courtesy of Vernetta Bergeon.)

Donald and Karon Covington, 1992. The Covingtons led the history committee of the North Park Community Association through the 1980s and 1990s. Donald authored the history of North Park's first 50 years, *North Park: A San Diego Urban Village, 1896-1946*, which was published five years after his untimely death in 2002. The couple also compiled research that enabled designation of the North Park Dryden Historic District in 2011. (Courtesy of the Covington family.)

North Park Historical Society, 2014. Some of the organization members who contributed to this book pose on the steps of the Lafayette Hotel. Achievements of the all-volunteer nonprofit that formed in 2008 include the listing of the water tower in the National Register of Historic Places, designation of the North Park Dryden Historic District, and production of two other books about North Park's history. Visit them on the web at www.NorthParkHistory.org. (Courtesy of Valerie Hayken.)

Discover Thousands of Local History Books
Featuring Millions of Vintage Images

Arcadia Publishing, the leading local history publisher in the United States, is committed to making history accessible and meaningful through publishing books that celebrate and preserve the heritage of America's people and places.

Find more books like this at
www.arcadiapublishing.com

Search for your hometown history, your old stomping grounds, and even your favorite sports team.

Consistent with our mission to preserve history on a local level, this book was printed in South Carolina on American-made paper and manufactured entirely in the United States. Products carrying the accredited Forest Stewardship Council (FSC) label are printed on 100 percent FSC-certified paper.

MADE IN THE USA